Looking for Leonardo

Naive and Folk Art Objects
Found in America by
Bates and Isabel Lowry

Looking for Leonardo

Naive and Folk Art Objects
Found in America by
Bates and Isabel Lowry

Text by

Bates Lowry

Published for the
University of Iowa Museum of Art
by the
University of Iowa Press

Published on the occasion of the exhibition *Looking for Leonardo: Naive and Folk Art Objects Found in America by Bates and Isabel Lowry*

Taft Museum
Cincinnati, Ohio
June 18 to August 15, 1993

The University of Iowa Museum of Art
Iowa City, Iowa
October 30, 1993, to January 2, 1994

Reading Public Museum
Reading, Pennsylvania
March 26 to May 22, 1994

Published by the University of Iowa
Press, Iowa City 52242
Copyright © 1993 by Bates Lowry
All rights reserved
Printed in the United States of America

In the following catalogue, dimensions are given in inches. Unless otherwise noted, height precedes width, which precedes depth or length. Dimensions do not include frames.

Library of Congress Cataloging-in-Publication Data
Lowry, Bates, 1923–
Looking for Leonardo: naive and folk art objects found in America by Bates and Isabel Lowry / by Bates Lowry.
p. cm.
ISBN 0-87745-441-8
1. Outsider art—United States—Catalogs. 2. Folk art—United States—Catalogs. 3. Lowry, Bates, 1923– —Art collections—Catalogs. 4. Lowry, Isabel—Art collections—Catalogs. 5. Outsider art—Private collections—United States—Catalogs. I. Lowry, Isabel. II. Title.
NK805.L68 1993 93-22167
745'.0973'07473—dc 20 CIP

97 96 95 94 93 P 5 4 3 2 1

Cover:
Map of the United States
Maker unknown
1930s–1940s
Lisle appliquéd on flour sack backed with sailcloth canvas, buttons, thumbtacks
19 3/4 x 25 3/4

Contents

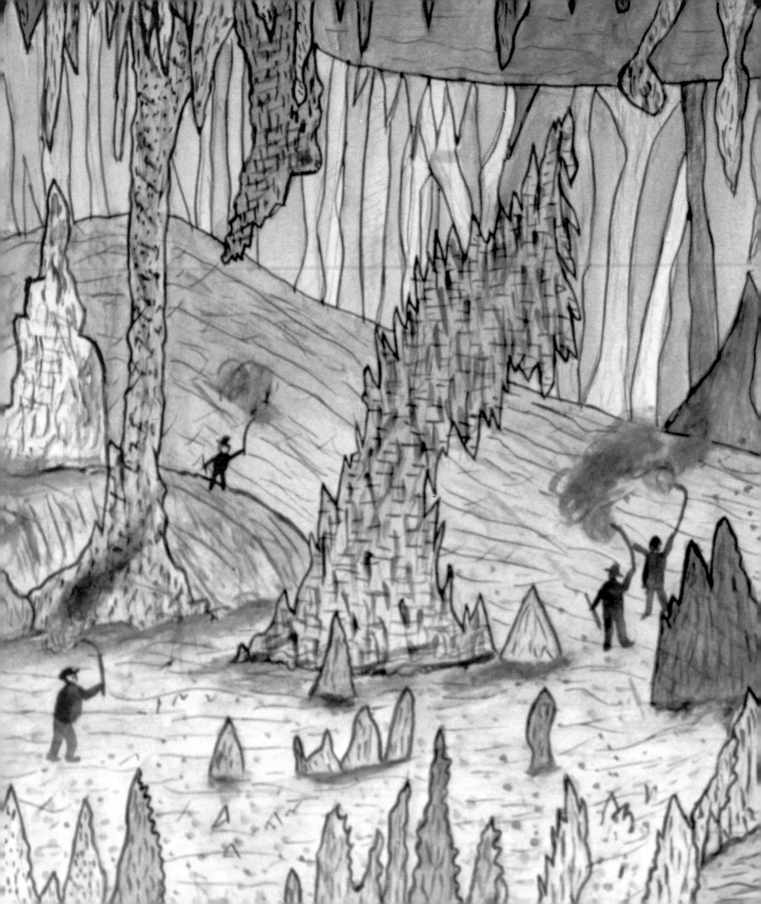

Foreword

It is with great pleasure that we present *Looking for Leonardo: Naive and Folk Art Objects Found in America by Bates and Isabel Lowry*, an informative and enchanting exhibition that, in a broad range of styles and media, surveys two centuries of American vernacular art.

The history of folk art collecting in America reaches back to the last years of the nineteenth century. It followed in the wake of the gradual recognition in Europe of the rich aesthetic vitality inherent in the artistic productions of distant cultures in Asia, Africa, and the Middle East, as well as, closer to home, in Eastern Europe's folk expressions. Artists were usually the first collectors in these areas, but others soon followed, recognizing and being captivated by the superb accomplishments in these traditions. Slower to find wide appreciation were the creations of naive or untutored artists, individuals whose productions were outside of existing traditions.

The Lowry Collection, compiled over four decades, anticipated much in the current fashion for folk and naive art. One of the principal joys to be found in the Lowrys' collecting is a hospitality to diversity that embraces many folk traditions and the eccentricities of naive production. What makes this collection exceptional is that most of the objects the Lowrys were attracted to are homemade, created for the maker's own enjoyment rather than for sale. All of this reflects a willingness to avoid established expectations in favor of a response to the innate artfulness of the thing itself, to the lively interplay of the parts and the whole, to a truly visual sense of the object. Most of the makers represented in the exhibition are altogether unknown, and still others are but a name, another form of anonymity. Yet all of them have fashioned objects and images, skillfully or diligently or crudely, that live as art.

Being among the ranks of the relatively small group of collectors gifted with a discerning eye, the Lowrys have brought another important quality to their collecting: Bates is a distinguished professional art historian, and Isabel is an avid and sensitive photographer under the professional name of Barrett McDonnell. The scholar-collector in this instance insures an unusually wide range of reference and information, here joined to the artist's subtlety of perception. Bates Lowry received his Ph.D. in art history from the University of Chicago and has held a number of academic and museum posts, among them teaching positions at Brown University and the University of Massachusetts as well as directorships at the Museum of Modern Art in New York and the National Building Museum in Washington, D.C. He has written on a wide variety of topics and was responsible for the formation of the Dunlap Society, known for its extensive pioneering documentation of American art; Isabel directed the society for over fifteen years.

viii

The Lowrys bring to their collecting a desire to explore the relationships between objects and the rich constellation of events—historical, social, stylistic, and practical—that inspired their creation. It is a pursuit that for many years has provided illumination and delight in understanding how people have lived in America for the past two centuries, a sense of pleasure that will be evident to the reader.

A publication such as this and the exhibition it supports are complex undertakings, the work of many caring and skillful people. There are too many to thank here. However, I would like to acknowledge some notable contributions.

Bates and Isabel Lowry generously and thoughtfully lent their possessions and provided helpful suggestions at every step in the realization of both exhibition and book. In addition, Bates wrote the splendid book and Isabel took many of the photographs.

This handsome publication was designed by Ab Gratama, assisted by John Fender. Additional photography was provided by Gene Dieken. Jo-Ann Conklin, curator, ably assisted in many editorial and production matters, and Pamela White Curran, curator, provided help in the preliminary organization of the exhibition. Donald Jeffrey Martin, registrar, skillfully managed the many details of shipping.

David Dennis supervised the exhibition's heartfelt installation. The rich and varied interpretive program accompanying the exhibition was designed by Emily J. G. Vermillion, curator of education.

I am delighted that we are able to collaborate with the University of Iowa Press in making this publication available to a wide public.

And, finally, I wish to thank the Iowa Arts Council and the Iowa Humanities Board for grants in partial support of the exhibition's educational component.

Stephen S. Prokopoff

Preface

The idea for mounting an exhibition from our collection was Stephen Prokopoff's. We are pleased that he convinced us that others would enjoy seeing the objects we were surrounded by in our home and that he persevered in turning his idea into reality. His doing so has allowed Isabel and me to renew our original feelings for these objects, and writing about them has made us even more conscious of why we were so attracted to the work of these mostly anonymous artists. It also has made us remember with gratitude the many wonderful individuals whom we met along the way who shared our insights into and enthusiasm for these objects, particularly the dealers who often were responsible for giving us the opportunity to encounter some of the objects we most treasure.

I owe a special debt to Randall Holton for assisting me with putting into words the reason for our quest. His perceptive reading of the manuscript and his suggestions have helped clarify my comments, especially in the chapter on marble dust paintings—of which he and his wife, Tanya, are passionate collectors. I also was aided by the discerning comments of Bernard and Barbara Kramer, Daniel Robbins, Carol Brownell Francescani, and Robert Metzger. In its final form the text has benefited significantly from Gail Zlatnik, its sensitive and helpful editor. My deepest thanks go to Jo-Ann Conklin who not only accepted my many demands about photographs, layout, and text in good spirit but succeeded in making the complex interweaving of all these parts into a successful unity. Ab Gratama exhibited great sensitivity to my text and at the same time created a book with a distinctive graphic presence.

Finally, we wish to dedicate this book to our children, Anne and Patty; their husbands, Fred and John; and our grandchildren, Jessica, Leigh, Evan, and Colin. It is our belief that being exposed to our obsessive passion has led them to appreciate, enjoy, and discover objects similar in spirit to ours. We also believe that by doing so they will come to have respect for and be sensitive to the amazing capacity for visual understanding that all of us possess and that is surely one of our most human qualities.

Bates Lowry

Made in America

How odd it seems for us to look at our random discoveries of over forty years as a "collection." We acquired a particular object (I refrain from saying "work of art") for its individual qualities, not because it "fit" with other works. What, if anything, holds this accumulation of objects together is our belief that each is the result of an extraordinary visual expression of the human spirit.

Each time an object came into our lives it was a moment of unique discovery. The object resonated in such a way that we felt it had been created especially for us, and by sheltering it we were somehow linked to the artist who made it. Thus the works we have gathered are the result of encounters with the personalities of their artists— but only as expressed in their work, since the largest number of our objects are anonymous.

Now that the moment has come to share these objects with others and to discuss them in the context of the chapters that follow, we are concerned that some readers may come to believe that we set out to search for a particular object because it fell into some category or other. This is not so. In fact, we believe that in some sense all of these objects found us! Our coming together has been accidental, though we encouraged such magic to occur by rarely overlooking the chance to visit a yard sale, flea market, secondhand store, church sale, antique shop or show. We were almost never disappointed. Objects always surfaced as if they had arrived there just for us.

But what was it exactly that we were hoping to discover? We have tried to answer—or perhaps evade—this question by describing what we have been doing as "looking for Leonardo." Ours is a deliberately enigmatic title which needs to be put into context. For us, "Leonardo" is not just a famous fifteenth-century artist who painted great masterpieces like *The Last Supper* or the *Mona Lisa*, but an artist whose visual curiosity could never be satisfied, and whose imagination and intelligence worked together to create or suggest solutions to the most daunting questions about human existence. Leonardo was concerned not just with problems of how to *represent* works of nature, but also with how they came into being and how they functioned. He even wondered if an ideal system of geometry might not underlie all of creation.

He recorded his ideas in hundreds of drawings and manuscript pages that reveal his incredible ability to visualize the physical world and its mechanical secrets. Leonardo also studied objects in motion—running horses, flying birds—as well as the movements of air and water. From such studies came mechanical inventions, not to be realized for centuries, as well as fantastic animated monsters to frighten and amuse the crowds at gala festivals

and processions. And he also took time from his concentrated studies to wonder at and be amused by the recognizable forms that could emerge from clouds as the temperature and wind shifted. Leonardo had, it seems, no limit to his inventiveness, no boundaries to his vision.

For us Leonardo also has a special personality because our understanding of him has been shaped by our association with one of his most sympathetic and sensitive interpreters, the late artist and scholar Kate Steinitz. A native of Hanover, Germany, she had been part of the original Dada group of avant-garde artists after World War I, and a particular friend of Kurt Schwitters, the great master of collage. In this country, she became either accidentally or by intuitive force so fascinated with Leonardo that she devoted the rest of her life to being a scholar of his work. When we first came to know her in 1954, Kate occupied a tiny corner in the library area of the medical building where her patron, Dr. Elmer Belt, had amassed his amazing collection of books dealing with Leonardo. To this spot came letters from around the world, since Kate had become the nexus for all those passionate about Leonardo. Questions and comments came from such famous scholars as Erwin Panofsky and Ernst Gombrich, and their scholarly correspondence mingled with letters from the artists of her other world—the Dada group.

We were lucky to be a part of Kate's world, and, thanks to her, Leonardo's imaginative energy came alive for us. We also were delighted to discover that her excitement extended to the kinds of objects we had been finding. We believe Kate would endorse our idea of calling what we have done *Looking for Leonardo.* She would share our unspoken hope that somewhere in America there existed a kindred soul of Leonardo, whose presence would become known by the discovery of some incredible work of pure visual imagination.

The more we considered it, the more we liked the idea of associating the spirit of Leonardo with the makers of the many diverse objects now standing before us, pleading for, if not demanding, some common denominator. *Looking for Leonardo* seemed to meet that need as well as to describe—with a certain degree of humor intended—our years of collecting. We see all of the objects we have brought together as evidence of that spark which passes between the eye and the mind, a moment of intuition and insight which transforms the object into a unique work. When we believe we can sense this moment in an object we also feel a common bond, a sympathetic understanding or empathy with the maker. Such objects immediately become attractive to us.

This happened, for example, the moment we saw the whimsical piece

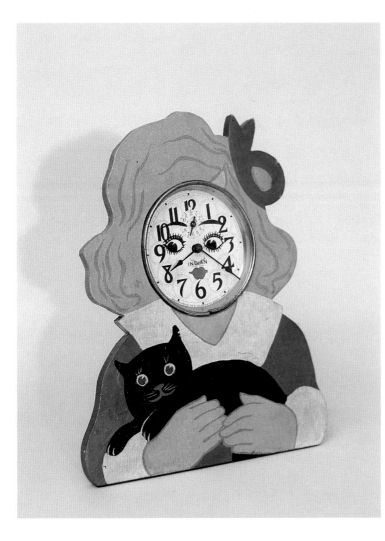

Fig. 1

The Face of Time

Maker unknown

1930s

Alarm clock and

painted wood

12 x 9 1/2 x 5

that is both an alarm clock and a work of sculpture (fig. 1). In fact this clock exists simultaneously in both realms. Its maker has painted the "frame" for the clock in the vivid colors of the Sunday comics, which may, indeed, have been where the artist formulated this image of the girl—a mélange of Orphan Annie and Betty Boop. The painted frame, with the cartoon simplicity of the ribbon in the girl's hair and the startling green eyes and red lashes of the cat, is

completed by the stylish Cupid's bow mouth and wide-open eyes painted on the clock itself. We cannot escape the artist's pun on the idea of a face, and the more we look at the work the more we enjoy its cleverness. Indeed, if we turn the piece around we see a hidden detail of construction that, by its utter simplicity, makes us admire the ingenuity of this artist. To prop up the piece so it could stand on a table, the maker used a simple metal coat hook, but placed it upside down. This piece shows the visual spark and creative mind for which we searched, and we think Leonardo would feel the same. We resist, however, thinking of it as the Mona Lisa of alarm clocks.

Other pieces that have become part of our collection show a similar sensitivity to visual qualities but are expressed in a more traditional manner. This brilliantly colored hooked rug is a prime example (fig. 2). A simple composition made up only of squares of different colors could easily be a pedestrian piece. This maker, however, knew instinctively that arranging the small squares of vibrant hues and shades in step patterns would create a mosaic design of enormous vitality. The maker organized the rug's design by dividing it into a border and a central area with a strong black frame. This frame comes into contact with the jagged diagonal lines of the border, making the entire rug appear to be overlaid by a cast-iron grill. This, in turn, produces the effect of enclosing

4

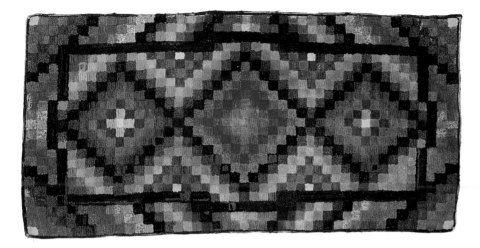

Fig. 2

A Radiant Mosaic

Maker unknown

ca. 1925

Yarn and fabric hooked

on burlap

26 x 53

some bands of color while making others appear to pass beneath it.

This masterpiece of a hooked rug seemed so special and individual that it almost came as a shock to discover, in a musty secondhand shop, another rug that excited us just as much (fig. 3). It, too, is an astounding work because of its maker's sensitivity to how the colors and shapes blend together to create the overall pattern. This maker also focuses on one simple shape—a crescent rather than a square—but brings these shapes together in a different way, creating a rhythm quite unlike that of the previous piece. The work is freer both because of the inherent movement in the crescent shape and because a rigid surface pattern is not imposed. Although this rug also has a border of variously colored rectangles, here the border does not contain movement but acts as a horizontal base from which the crescent shapes sprout as if they were plants. Different organic forms that project into the composition from the

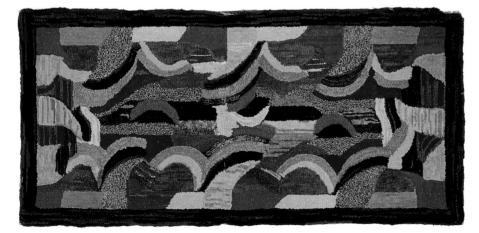

Fig. 3

Curves of Color

Maker unknown

ca. 1935

Yarn and fabric

hooked on burlap

22 x 48

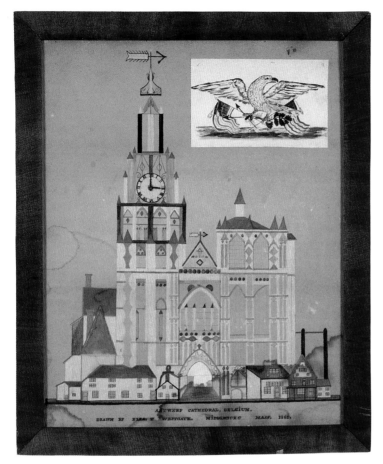

Fig. 4
A Colorful Cathedral

Inscribed "Drawn by Ezra
T. Westgate / Middleboro /
Mass. / 1862."
Ink and watercolor
on paper
23 3/4 x 19 3/4

the necessary ability to do so. Works produced by artists with the same assurance, but with less skill, have also fascinated us. How magical such works can be is clear from a drawing of the Antwerp Cathedral made in 1862 by Ezra T. Westgate (fig. 4). Isabel and I are in some disagreement about whether this work by Ezra is the product of the innocent eye of a child or of the untrained hand of an older person. This question is not easily resolved, but an answer is not truly important since, in either case, our pleasure in this piece comes from the object itself, not from any knowledge about its maker. Ezra has given us a work of fancy in which he has translated the architectural components of a Gothic cathedral into forms that are closer to toy building blocks than to carved stone and masonry. We can even imagine that the vertical red-tipped elements clustered on the towers might have been inspired by birthday candles rather than medieval pinnacles. Although he accurately followed the basic architectural form of the cathedral, Ezra dressed it in a colorful, stylized manner that gives such a punch to the image that the building becomes his own creation.

shorter sides of the rug add an even greater sense of uninhibited movement. The horizontal central area becomes an undefined space of darker hues in which small crescent shapes seem free to spring about at will. Equally impressive pieces when stretched on the floor, this rug and the previous one show how each is the product of the personal visual language of its maker.

All of the works we have looked at thus far have been the products of confident artists—ones who not only had a clear idea of what they wanted to achieve but

America's visual world was vastly expanded during the early part of this century when weekly magazines like the *Saturday Evening Post* began to use color reproductions of works of art on their covers and advertising pages. Such artwork flooded the nation's

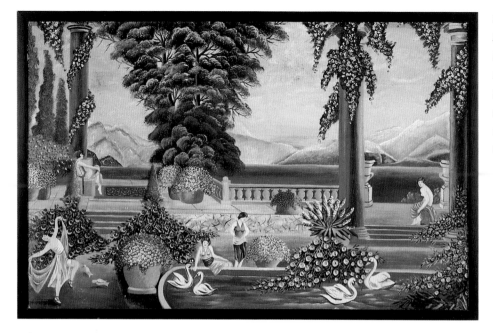

Fig. 5

Dreams of a Harem

*Signed on reverse "John
H. Stover, York,
Pennsylvania"*

ca. 1920

Oil on board

22 3/4 x 35 1/2

homes on calendars, candy boxes, and even on paper fans, many of which were given away by merchants to advertise their products. Most of the imagery used in this fashion was derived from the classical dream world of Maxfield Parrish, whose nymphs, urns, vine-clad columns, and distant purplish mountains became the language many artists tried to speak. The desire to paint these adolescent fantasies of a golden age was pursued by many amateur painters, but we found only one who managed to do so in a way that made this commercially manufactured world seem both humorous and heartfelt.

We say this about our work by John H. Stover of York, Pennsylvania (fig. 5), even though we were later to learn from a chance flea-market discovery

that the ambitiously posed dancing nymph is a direct copy of a nymph featured on a paper fan distributed by a local funeral parlor! Whatever other sources he might have turned to for help in embellishing his dream, we are positive none will be found that match his wonderful technicolor world, or will show with such devotion each blossom in the wide array of drooping vines and flowering bushes he provided for this pleasure garden. His plant forms are so luxuriant that they resemble the ideal types seen only on the fronts of seed catalogues, and his nymphs are clothed—with one daring exception—in outfits not too far removed from a mail-order catalogue from Sears, Roebuck.

It is unlikely, therefore, that we will discover any particular artwork that Stover was attempting to copy. Rather

he has adopted the overall imagery of work in the Maxfield Parrish vein and filled it out with details taken from more mundane sources. This assumption is borne out also by the brilliant colors Stover uses—more like the chips in an enamel-paint sample book than the cool colors of a Parrish print. We believe that in these ways Stover surpassed the ideal subject matter he wished to create. Through his own values and naive eye he has made—unwittingly, no doubt—a biting and amusing comment on the work of those who only see through the eyes of another.

a more graphic, dramatic image. To create a bold design, however, was not why this particular symbol was chosen. The maker primarily wanted to rely upon an image already existing in people's minds—particularly during the 1930s and 1940s—as a symbol of their everyday world. Choosing one associated with a product that later would be canonized by Andy Warhol was fortuitous, not prophetic.

The artist of the colorful still life (fig. 7) also was creating a work within an accepted formula. Arrangements of fruits and flowers were frequent subjects for amateur painters during the mid nineteenth century. Some were painted on canvas, others on velvet (known as theorems), while still others were done with pastels or watercolors, and a smaller number were painted on the back of a piece of glass (creating what are known as reverse paintings). Because our painting is on glass, it possesses a rich glowing surface. The principal reason, however, that the impact of this work is so strong is the simple compositional scheme employed by its maker.

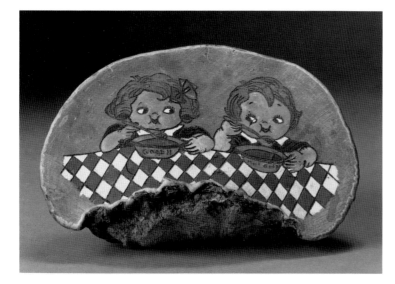

Fig. 6
Mmm Mmm Good!
Maker unknown
ca. 1940
Woodburning and poster
paint on tree fungus
7 x 10 1/2 x 4

A more direct borrowing—but not an actual copy—of a recognizable visual image is the bold depiction on a natural tree fungus of a commercial icon—the Campbell Soup Kids (fig. 6). The strong wood-burned outlines and colorful patterned tablecloth transform the well-known advertising symbol into

The message conveyed by this painting is that nature's generous bounty is overflowing. The artist suggests this idea here by dividing the painting precisely in half with the horizontal band of the graceful compote, whose shape is almost the sole object to occupy the lower section of the painting. The fruit, crowded into

the upper half, at first appears to be arranged loosely and to be spilling out of its container, but is actually settled within a balanced arrangement of grapes on either side and anchored by four prominent green leaves. The gratuitous calligraphic swirls that

presumably a watermelon dominate and crowd the rest of the fruit. The apple, cherries, and strawberries are simply decorative spots of color, impossibly placed as pieces of fruit but brilliant as part of the overall ornamental pattern. In fact, if one looks closely one

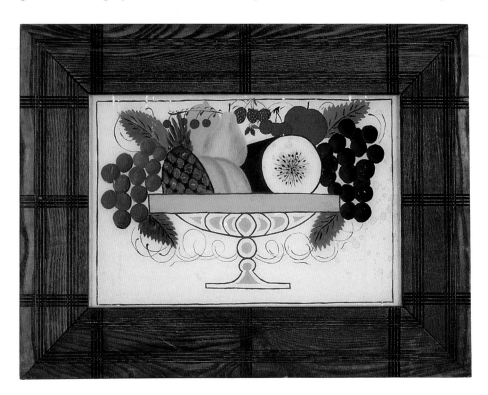

Fig. 7
Nature's Overflowing
Bounty
Maker unknown
ca. 1850, with later frame
Reverse painting on glass
12 x 18

connect these leaves—acting almost like a net thrown behind the bowl of fruit—further embellish the decorative scheme.

With this compositional framework established, the artist's imaginative sense of color and form is then free to fill the central space with sharply contrasting shapes and textures. The fabriclike skin of a pineapple and the glistening white slice of what is

can see that each piece of fruit is given its position because of its role in a visual composition, not because of any logical placement due to the actual weight or size of the fruit or to any true scale between them. The powerful effect of this painting and the clarity of its message results directly from this artist's desire and ability to create an abstract composition of color and shape rather than simply to represent an overflowing compote of fruit.

Fig. 8

Hurrah!

Maker unknown

1870s

Wool and cotton pieces sewn on

unbleached cotton backing

38 x 43

Although this still-life painting is a work based on natural objects, the principles of its design are not dissimilar from those followed by the makers of these two geometrically designed table covers which use circular coinlike pieces of fabric and are commonly called penny rugs. In the piece which we call *Hurrah!* (fig. 8) the maker's adept fingers and instinct for formal composition give this work a celebratory appearance which is due both to the size and hues selected for the brilliant felt circles, or "pennies," and to the forceful scheme of alternating light and dark in which they are arranged. The care taken by the artist in cutting each piece to match its neighbor and in sewing them together with almost invisible stitches enhances the overall flatness of the design which is so critical in conveying the sense of decorative perfection the maker was seeking.

Fig. 9

A Glowing Hymn

Maker unknown

1870s

Wool pieces sewn on linen

backing

41 x 36

In the same way the hooked rugs we discussed earlier (figs. 2, 3) have similar but contrasting appearances, the cover just described also has a complementary piece (fig. 9) which demonstrates how different the nature of such comparable works can be, depending upon the intention of their makers. In this instance, the maker created a richly textured piece by piling up the "pennies" following a carefully modulated color scheme of brown and gray activated by areas of blue and red. Because each stack is identical in size, the overall composition results from the pulsating energy each piece contributes to the whole. The contrasting colors at the center of each arm of the six-pointed star almost seem as if they were illuminated from behind. This effect lends associative values to the piece,

placing it in the realm of a decorative and symbolic art form akin to the geometrical confines of Islamic art.

Sensitivity to visual form may exist regardless of whether the maker is a painter, sculptor, or architect. The

such compelling objects? Their size, the directness of their purpose, and their homemade quality. A similar pair of shoes, manufactured, for example, by the Buster Brown shoe chain, would be a great advertising collectible but not a work of the human spirit. This

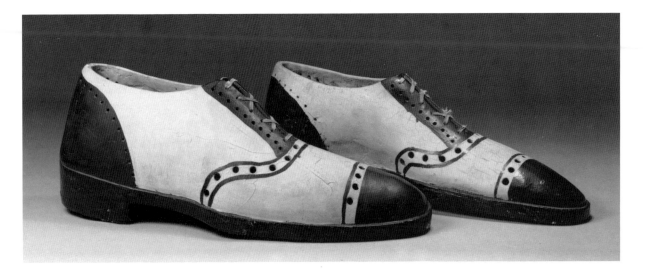

creative imagination is a potential force within everyone, as is demonstrated by this enormous pair of men's spectator shoes made by the owner of a shoe repair shop in Chelsea, Massachusetts (fig. 10). When he first opened for business in the 1930s he fashioned these papier-mâché shoes for his store window where, with a red light bulb inside them for illumination, they served as a creative symbol of his work. A friend and I found them as the proprietor was going out of business and, happily, convinced him that his creations should continue beyond the life of his shop. What makes them

pair of shoes is the product of someone whose visual imagination is worth remembering.

The presence in this shadow box (fig. 11) of an arrangement of different kinds of objects suggests that its maker had a message, though its meaning is beyond our understanding. Leonardo, of course, would have been intrigued by its implicit riddle. He, a lover of the rebus and the enigmatic inscription, would probably have immediately proposed an answer to this box. But why do we think the maker of this work intended to create anything more than a work of formal

Fig. 10

Cobbler's Dream

Joseph Iacoviello, shoemaker,
Chelsea, Massachusetts
1930s
Plaster of Paris with cloth laces,
wired for electric light
11 1/4 x 10 1/2 x 31 (each shoe)

Fig. 11
Sounds of the Sea?
Maker unknown
Date unknown
Various manufactured
objects
17 x 12 x 4

beauty, following a superior sense of color, shape, and balance? We are led to do so primarily because in addition to a distinctive visual quality, each object also has such a specific character, particularly when arranged against the front page of a Boston

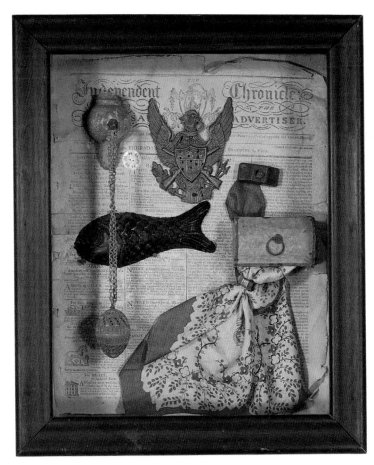

American artist Joseph Cornell. Although it has been suggested that this piece is a "memory box" made by a sea captain from items intended to highlight moments in his life, we have never been able to verify such an explanation. In fact, we have never found another box like this one. The piece remains a beautiful mystery, a mute statement by an artist who spoke a clear visual language.

This unexplained object is one example of the works we have sought out over the past forty years—works we believe are the product of people who share, if only faintly, the delight of discovery and the all-encompassing eye of Leonardo.

newspaper dated December 1, 1800. So we cannot help but wonder what led the artist to choose these objects and bring them together within this box. And for an art historian it is difficult not to see this work in the same light as the enigmatic boxes made by the late

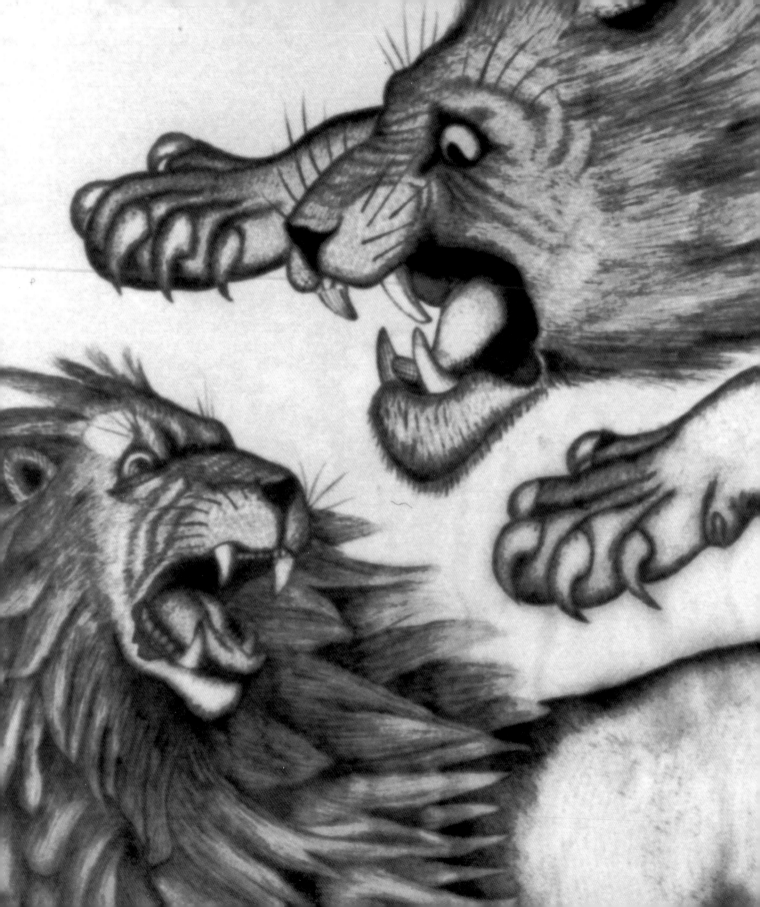

Pencil, Pen, or Brush

Of all the objects we have collected, drawings have instantly engaged our eye because in them the artistic process is so easily observable. The union of the acts of seeing and making is especially evident in children's work, of which we have been lucky to find some revealing examples.

The innocent eye and the free hand of childhood can be seen in the album we discovered at a yard sale in upstate New York. Initially used as a merchant's

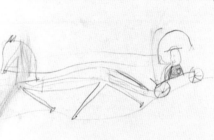

Fig. 12

A "Rainy Day" Book

Anson L., Frank L., Walter, and Louise M. Bentley

ca. 1850

Bound ledger of more than 264 pages, leather spine and marbleized boards, drawings in pencil

7 1/2 x 6

ledger (from 1825 to 1833), its remaining pages were filled with lists of words, calculations, tick-tack-toe contests, and drawings made by at

least four children in the Bentley family. It provides a rare glimpse of how each of them recorded what apparently was the most impressive part of their surroundings—the horse. For these farm children of the Adirondacks, the horse appears to have dominated everyday life more than any other animal. Their scribblings are filled with drawings of horses running free or harnessed to plows, carriages, and sleighs.

Taking two pages at random from the album, we can sense how the children struggled with their pencils to set down the essential aspects of their subjects (fig. 12). The child who drew a horse swiftly pulling a wagon elongates and streamlines its body and slims down its legs to express forceful strides. Speed is what this artist saw and was able to convey even in this crude drawing. Another child shows the horse going up a hill, exerting all its energy to pull along the farmer, who is standing on some type of board. In this case, the maker carefully delineates the leg joints, emphasizes the rump and mane, and details the harness. This child has also been successful in giving us a clear sense of the particular action he wanted to depict, despite his equally clumsy drawing skills. Paging through this album is a constant joy, as we see sketch after sketch that reveals so clearly what the children wished to record and their special ways of doing so.

We found two very different, more ambitious children's works which

appear to have been made in the same classroom, perhaps kept by their teacher for exhibition on parents' night. They share a similarity in size and technique, as well as a numbering system on the reverse. Despite these common characteristics, each of these two very colorful pieces shows a distinctive personality at work. The child who painted the anglers fishing beneath the rocky cliff (fig. 13) did so with great exuberance and imagination, placing in the sky not only the sun but the man in the moon. Unhampered by any preconceived idea of what a work of art should be, the artist shares with us both a personal vision of the event and the tactile joy experienced when moving the brush to create the swishing fly rod and a mass of swirling birds.

The other work is by a child whose view of the world and use of the brush are very different (fig. 14). This child concentrates on solidly constructed objects and delineates the house, tower, viaduct, wall, factory, and chimney with great care, creating a view of a community safely protected from the sea. This artist's single-minded focus on trying to get down on paper the three-dimensional qualities of the solid objects suggests a precise, keen observer of the world, with a mind-bent very different from that of the other, more carefree child.

The innocent eye of childhood frequently disappears when children

are taught how to draw. A standard method during the nineteenth century was to provide students with a drawing exercise book whose illustrations they were expected to copy. We were pleased to find an album produced by a pupil following this method. Her name, Amanda Ames, is inscribed on its cover and she probably made it while a student at the academy in St. Johnsbury, Vermont, as a view of that school is included in the album. The drawings begin with simple geometric

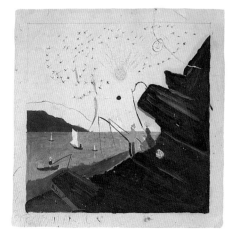

Fig. 13

Anglers on a Rocky Shore

Signed on reverse "Charles W. Stevens" and "Charlie" and numbered "8"
ca. 1910
Watercolor on lined paper
6 x 6

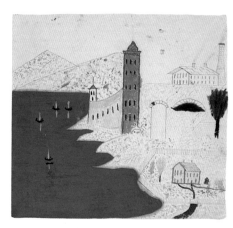

Fig. 14

A Snug Harbor

Maker unknown, initials "H M S" on reverse and numbered "10"
ca. 1910
Watercolor and pencil on lined paper
6 1/4 x 6 7/8

exercises, proceed to studies of rocks and trees, and conclude with views of different monuments and landscapes (fig. 15). Amanda made none of these drawings from nature or at the actual site; all were created by copying pages

illustrations: drawing exercise books, prints in magazines, illustrated history and religious texts, separate engravings, lithographs, and, later in the nineteenth century, photographs in a variety of reproduced forms. Whether or not we

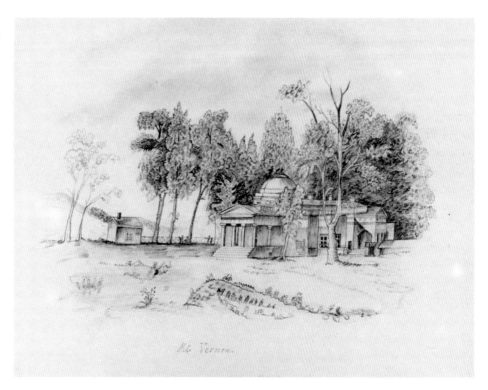

Fig. 15

Lesson Book of

Amanda Ames

Signed on front cover

"Amanda Ames"

ca. 1850

Pencil on paper

8 1/2 x 11

from a published drawing book. An amusing slip in this album, and perhaps a glimpse into the student's half-hearted involvement with her task, is her identification of the carefully delineated view of Monticello as "Mt. Vernon."

Amateur artists or students normally used preexisting illustrations as guides when trying their hand at making drawings or paintings on their own. There were many sources for such

know the exact source of the artist's inspiration, we usually can detect when one was relied upon. Such works of art then become fascinating puzzles as one tries to determine how the artist interpreted the source of inspiration.

One drawing by an amateur artist (fig. 16) was clearly made by following some prototype, even though we have not been able to identify it precisely. We suspect this is so because of the

amateurish drawing and because the subject of the work is a truly daunting one even to the best of artists. In fact, the pose chosen to be depicted is frequently used as a test of skill in academic drawing classes, and artists from Titian to Picasso have made paintings of this subject. In this drawing, the defining pencil lines seem hesitant—perhaps produced slowly and laboriously—as the artist attempts to set down on paper the woman seen at an oblique angle, head twisted about to look into a mirror as she combs her hair. Even to copy a preexisting illustration demanded more understanding about the art of drawing than the artist possessed. What makes this drawing so appealing is the artist's determination to achieve such an ambitious work and the sincerity with which it seems to have been done.

A drawing which must have been based on a photograph is this childlike delineation of Niagara Falls (fig. 17). With the camera's eye to guide the composition of the drawing, the artist is able to give a convincing representation of the site even though the drawing of the trees and buildings is simplistic. The artist also lacks the maturity to read the flat black-and-white surface of the photograph in terms of the actual space represented, and so diminishes the vast expanse recorded by the camera to a much more limited scene. This constriction of distance works to the artist's

Fig. 16

"The Morning Toilet"

Maker unknown

ca. 1895

Pencil and crayon

on paper

20 x 13

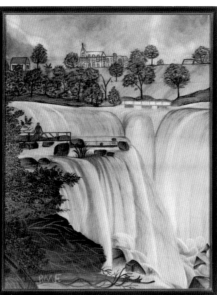

Fig. 17

A Raging Waterfall

Maker unknown, initials

"P.M.E." at lower left

ca. 1910

Charcoal on paper

25 x 20

advantage when depicting the falls. The sweeping water is so crowded within the tight space of the foreground, its force so convincingly conveyed, that it seems as if we can hear the roar.

The painter who gave us this oil view of Lake George (fig. 18) did so by copying almost exactly a well-known engraving of the scene by W. H. Bartlett first published in 1840. As in the print, the trees are shown growing at different angles to emphasize the wildness of the setting, but the painter uses a palette of colors to intensify the contrast between the trees and the distant mountains. By highlighting the deciduous trees in the center and the

to the rowboat. This use of color gives to the scene a grandeur the print can only hint at in its black-and-white imagery. It also gives us another chance to see how a preexisting illustration can be turned into a different kind of work by virtue of the artist's personal vision.

Sometimes the point of departure can be so altered by an artist that the resulting work can be seen as almost

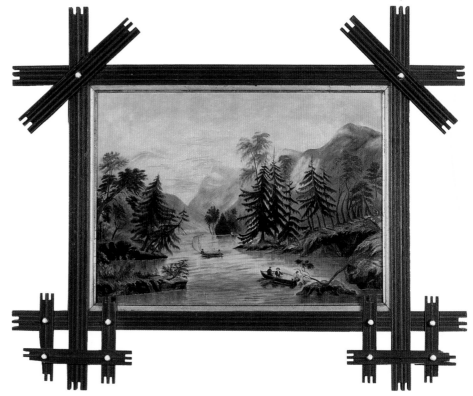

Fig. 18
Boating on Lake George
Maker unknown
ca. 1890
Oil on canvas
26 1/2 x 32 1/2

far left in a brownish red, the painter sets up an area of intense, sunsetlike atmosphere which is made even stronger by its reflection in the waters of the lake, particularly in the area next

completely original. Picasso often created works in this manner, paying his respects to the works of previous artists like Velásquez or Delacroix. Amateur artists may not be in Picasso's

realm, but occasionally they too create works after a famous painting that are so personally rendered that they have a quality all their own. Such is the work we found in a yard sale (fig. 19) to which it had been brought by a prison guard from the nearby Dannemora, New York, correctional facility. It was the work of an inmate with whom the guard had traded art materials for finished paintings. A long inscription on the back identifies the artist as an "American Indian" by the name of Richard Tompkins, who claimed to have had several "one-man" shows in Manhattan before being imprisoned.

We wish we knew what his other paintings might be like, for, judging on the basis of the piece we found, he was an artist with a truly sensitive eye. Our work was painted after a reproduction of a popular portrait by the eighteenth-century Scottish painter Sir Henry Raeburn. The soft, misty atmosphere found in the Raeburn painting is violently altered in Tompkins' work to become a flat backdrop of strong hues—the blue and white of the sky and the dark brown of the earth. Although the sunlight of the Raeburn painting is replaced by an almost artificial illumination, the copyist is still able to make the pink satin costume stand out with a lushness similar to that of the original painting. He has done so by tightly holding the boy in the pincers of the dark areas on either side and by making the deeply cut white collar

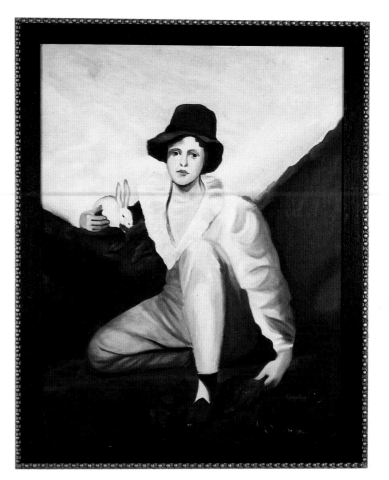

stand out by laying down the oil paint so heavily that it is almost freed from the costume. The straightforward, disengaged stare of the boy is a modern transformation of the sweeter gaze of the eighteenth-century original, while the almost ludicrous delineation of the rabbit is more from the world of cartoon than nature. To transform a much-beloved painting into a work that becomes a comment on, rather than a copy of, the original is the mark of a truly talented artist.

Fig. 19

Boy with Rabbit

Signed lower right
"Tompkins"; on reverse
"Richard Tompkins . . .
American Indian . . ."
ca. 1940
Oil on board
33 1/2 x 27 1/2

Unlike the previous artist, who had a strongly independent vision, some artists train themselves to see the world through the lens of an accepted artistic tradition. Few of these artists produced work we found attractive; by being less individualistic their work seemed dull in idea and unexciting in execution. We did make an exception, as I have already noted, in the case of the dreamer-artist John H. Stover (fig. 5), and we did so again for an artist whose work we became interested in when we encountered many examples in the Lake Champlain area. We could recognize the paintings not only by their characteristic style but because each was signed conspicuously: "J. F. Douthitt, N. Y." All were painted on a special type of cloth, known as bengaline, whose principal use was for painted stage sets, parade banners, or other forms of temporary decoration. This artist aspired to be one with the academic painters and to contribute to their world of classical nudes and exotically garbed models, but the desire to emulate their work far surpassed this artist's skills. Nevertheless, we became fond of this itinerant artist who had probably provided this part of the American countryside with a good portion of its "art." So when we came across what we knew to be the largest and best of all the works of Douthitt we had seen (fig. 20) we could not resist acquiring it.

In this work a nymph is posed languidly reclining in a tree which has grown in a manner especially convenient for her support. Her figure is only vaguely defined through the folds of her gown, the drooping sleeves and waving drapery hinting at the windy heights she has reached. What arboreal nymph is this who reclines high among the birds in the treetop? And for what purpose was this risqué work created? Where within this rural area had she resided before we found her? Questions like these increased this

Fig. 20

Arboreal Spirit

Signed lower right
"J. F. Douthitt, N. Y."
ca. 1895
Oil on bengaline
52 3/4 x 38 3/4

work's fascination for us. It is one of the few pieces whose visual inadequacies we have overlooked in favor of its interest as a cultural artifact in the development of art in America.

Sometimes we are certain from the appearance of a work of art that it is an attempt to depict an actual scene—either one at hand or a recollection. This pen-and-ink view of a woodland glen (fig. 21) gives us this feeling. It has a casual, almost snapshot appearance; the visitors and horseback rider seem to be distributed at random across the scene. We are not conscious of the artist's device of

using crossed diagonals in the lower section to define the foreground space and to hint at the distance in the scene. This compositional structure is obscured and softened by the web of detail the artist's delicate pen has spun across the surface. The artist almost never allows our eye to escape from this enclosed space; every detail of this leafy bower is so persistently recorded that we feel compelled to stay within it. We are drawn into its mottled light and shade and thereby share in the artist's record of visiting this sylvan glade on a summer day in 1868.

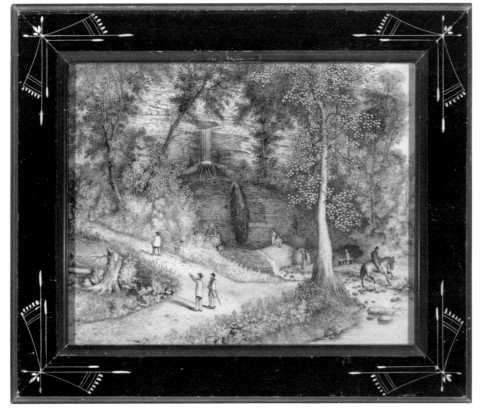

Fig. 21
Sightseers at the Falls
Maker unknown
Dated "Aug 16, 1868"
Ink on paper
10 5/8 x 13 5/8

Fig. 22

Deer in the Snow

Maker unknown

1880s

Oil on canvas

40 x 23 3/4

We have this same conviction about the painting *Deer in the Snow* (fig. 22). Its artist wishes to record a winter day when the deer were forced by the snow covering to venture to the outskirts of the village in search of food. The silent scene is set for us almost as if it were taking place on a stage. Two strongly silhouetted trees of different kinds reach nearly to the top of the elongated canvas, setting a scale for the painting and providing a decorative pattern for the surface. The depth of the immediate foreground is defined by the stark fence projecting from the left and the pile of snow-covered logs on the right. This area becomes the spotlit center of the stage onto which has stepped the larger deer, his smaller and perhaps more timid companion remaining behind in the middle ground, partially obscured by the pine tree. Problems arose for the artist when, to include the rest of the chosen subject, it was necessary to move upstage from the front. Set midway between, appearing like a brilliant jewel in the snow, is the red house, encircled by the gray roadway which was this artist's not-too-successful device for leading our eye back into the painting. This attempt to link the tiny, distant houses with the deer in the foreground does not quite work to define depth, but as a curving shape on the surface of the canvas it enhances the ornamental qualities of the painting and reinforces our belief that this artist was trying to record—however naively—what had occurred on a winter's day.

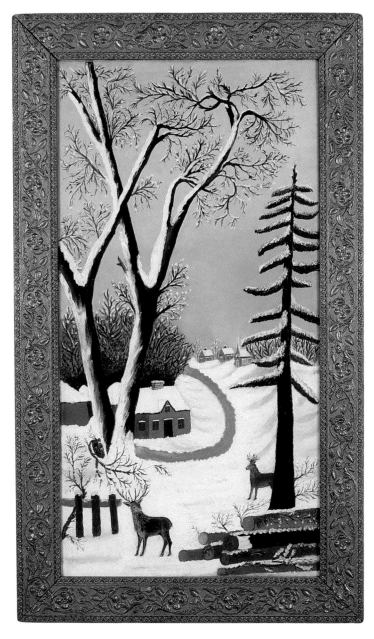

Some drawings immediately declare their independence from any preexisting source, like this calligraphic drawing of four birds made by Mrs. E. B. Barnett around 1850

(fig. 23). She has provided the most minimal of settings. Bare branches project from both sides and the bottom of the composition. They establish the frame within which we see the birds, suggesting that they exist in a specific space like a winter garden outside the artist's window. The sparseness of the setting is not unusual in this kind of work, for Mrs. Barnett was not as interested in creating a representational scene as she was in showing off her skills as a limner. While Mrs. Barnett focused primarily on depicting the details of the different birds, she still felt an obligation to provide them with a setting, to anchor them in place, perched in a circle above her signature.

An even more commanding way of claiming the pictorial field can be seen in a work of calligraphy that we were lucky to find among a lot of household goods at a country auction (fig. 24). The skills of the accomplished calligrapher who penned these lions were far superior to those of other "professors" of penmanship who often included depictions of lions in advertisements of their abilities. The images in their work, unlike those of this drawing, are made up of curlicues and calligraphic flourishes—more ornamental symbols than naturalistic drawings.

The facility the artist displayed in the use of the pen resulted in minute,

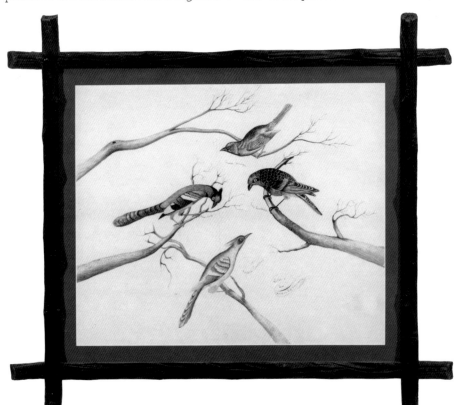

Fig. 23
Backyard Gathering
Inscribed "With a pen by Mrs. E. B. Barnett"
ca. 1850
Ink on paper
24 1/4 x 28 1/4

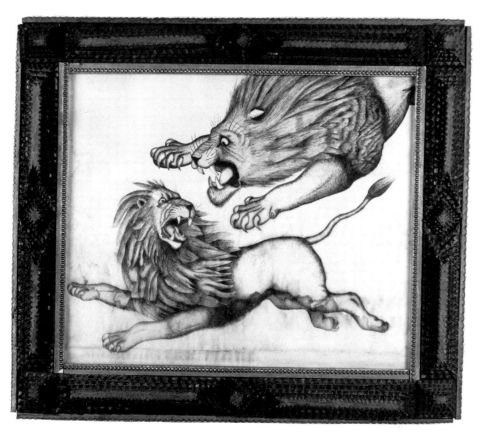

Fig. 24
A Fierce Encounter
Maker unknown
ca. 1890
Ink on paper
17 1/2 x 20 1/2

detailed descriptions of the hairy manes, smooth skins, and cruel, sharp fangs and claws of these beasts. The supremacy of this artist's talent can be seen in the multitude of fine lines that make the hair of the manes fly in the wind, the muzzles bristle, and the claws gleam, which together give a gripping immediacy to the battle between these two ferocious kings. The way the artist has shown one lion leaping into action from outside the frame intensifies the effect. Unlike the branches that stiffly project into Mrs. Barnett's drawing, the lion bursts into the scene so powerfully that he totally activates the space in which the attack is taking place.

This artist's description of the lions is so convincing that we are loath to believe that this drawing could have been influenced by another work. Yet a question does arise. Where could this artist possibly have seen such lions? Searching for an answer brought to our minds the snarling, pouncing lions on the brilliant red and yellow posters we used to see pasted around villages before the circus arrived at the county fair. If these were the source of inspiration, then this artist's pen has turned a gaudy broadside into a dramatic representational drawing.

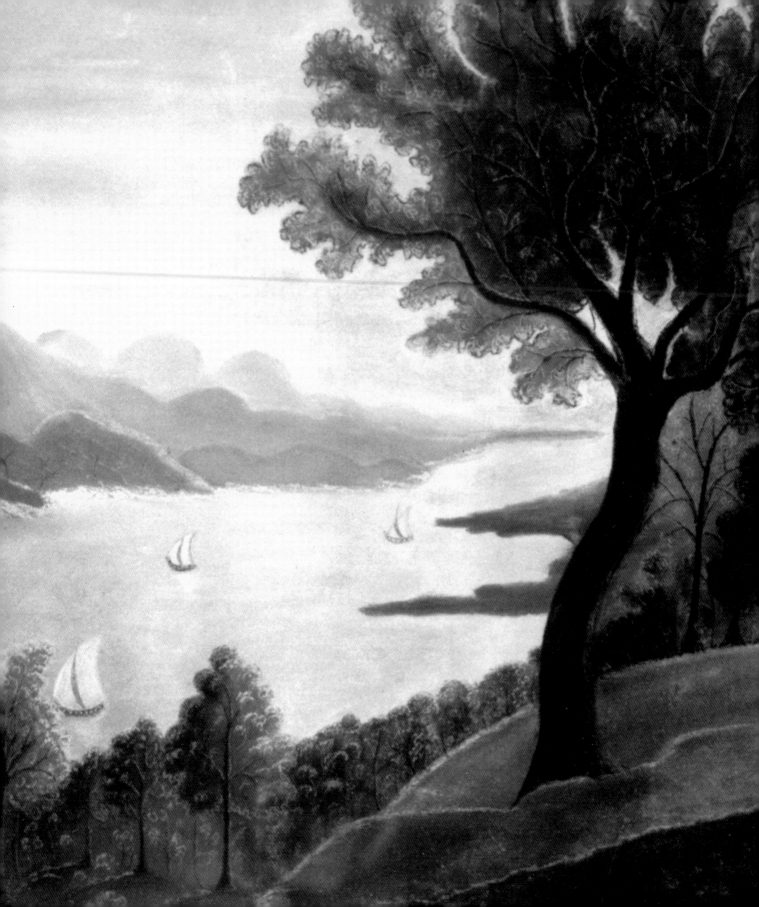

Marble Dust Paintings

Early in our search through flea markets and antique shops we were struck by some curiously appealing monochromatic works of an exceedingly distinctive appearance. They were unlike any other drawings or paintings we had seen and often portrayed haunting scenes characterized by strong contrasts between deep blacks and brilliant whites on a glistening mica-like surface.

As we began to come across more of these unusual works we tried to find out something about what seemed to us to be a unique art form. We were frustrated to discover only scant reference to them in books on American folk art and also to find that most dealers and collectors had no interest in these works. Because of their "dark" appearance they considered these works to be too funereal to be desirable and believed most were of European origin—not American—and made in the late nineteenth century. This judgment ignored the specific American subjects of many of the drawings, as well as the dates actually inscribed on some of the works, most of which placed the drawings in the 1840s through the 1860s and, in one case, as early as 1826. We ultimately discovered that there were many different types of these works and that they existed in amazingly large numbers. As a very popular art form over a long period of time, the works exhibit a wide range of quality, from very feeble attempts to supreme achievements. Those we found personally attractive were not, however, those that were the most expert technically, but those whose makers had successfully used the method to convey a personal view.

To understand these works more thoroughly we read instruction books published during the nineteenth century describing different types of objects "ladies" could make to decorate their homes. There, among the embroideries and crafts, the manuals described the method of creating these monochromatic paintings. While now often referred to as sandpaper paintings, we prefer the terminology "marble dust" paintings, since powdered marble was the material actually used for the surface of these works. The maker had to prepare, or purchase, a special paper that had been covered with a thick layer of white lead paint and then completely coated with the dust of pulverized white marble, giving it a sparkling white surface. In some cases this surface ultimately becomes the white portions in the finished design; the darks and grays come from the successive application and careful blending of charcoal—either as sticks or as a powder applied with brushes, leather pads, corks, or sponges. Whatever dark lines exist in the final piece were added by sharp strokes of black charcoal, white lines being made

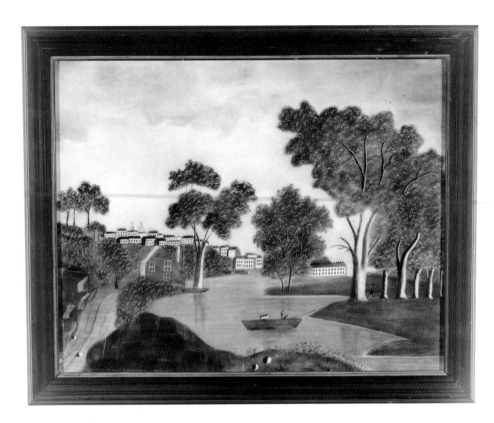

Fig. 25
View of Albany, New York
Maker unknown
ca. 1850
Charcoal and chalk on marble
dust board
20 x 26
(photo by Tony Walsh)

by actually scratching through the darkened portions to expose the original sparkling white surface or by adding white chalk. The finished work is thus the result of an involved process that had to be learned either from the simplified instructions in the manuals of the time or from lessons taken from a drawing master. Such instruction could be had either privately or as part of the art training offered in female academies.

Drawing teachers in these institutions were expected to help their students complete a work so it would look impressive when hung on the parlor wall of the student's tuition-paying parents. Many teachers did so, as we are told in some accounts of their experiences, by drawing or painting in parts of the student's work themselves—a fancy sky here, a flower garden there. Another practice followed by the drawing instructor to help students achieve admirable works of art was to provide them with engravings, etchings, or woodcuts to copy. In the same way that drawings by amateur artists or students were based on such sources, marble dust paintings were also derived from prints the students chose for their inspiration. With the print for a guide, any questions the student might have on the distribution of light and dark within

the overall composition, or the scale and arrangement of the objects, were already answered.

How such an engraving might be transformed into more than a mere copy through the use of the marble dust technique can be seen in one of our most primitive works (fig. 25), which is based on an undated engraving entitled *Albany, from Van-Unsselaens Island* by J. Archer (fig. 26), which in turn was made after the 1820 painting of this scene by William Guy Wall. The carefully modulated lights and darks making up the harmonious composition of the engraving have been abruptly changed in the marble dust painting to create a harsher, more strident reality. This maker seems to have been enraptured by the possibilities inherent in the bright white marble dust surface. The broad sky, the river, and the uphill road were brushed over only lightly, giving an overall brilliance to the scene. The full power of the startling white undersurface is used in the depiction of the toylike buildings of the town. As part of the maker's fascination with bold contrast, the tree trunks and the sharply defined rocks along the road on the left and in the foreground are heightened by adding a heavy coat of white chalk to their surfaces. The rocks shine so brightly they look as if they have been whitewashed.

Fig. 26
"Albany, from Van-Unsselaens Island"
*Engraving by J. Archer
after painting of 1820 by
William Guy Wall
Undated
5 x 8*

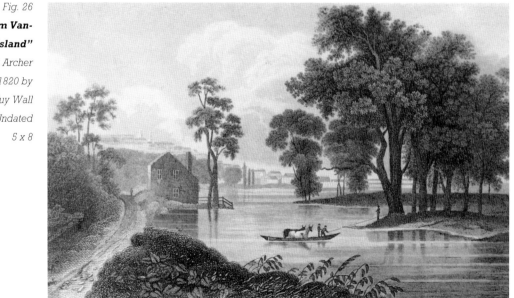

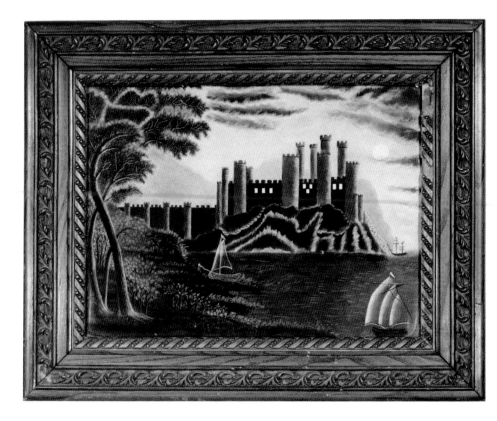

Fig. 27

**Conway Castle in
Moonlight**

Maker unknown

ca. 1840

*Charcoal and chalk on
marble dust board*

14 1/2 x 19 1/2

Moonlit scenes were favorite subjects for marble dust artists because the medium has such a powerful potential for producing strong contrasts of light and dark. One of our earliest acquisitions was a work by an artist who understood what a dramatic effect a moonlit setting could have on a scene (fig. 27). How much of this drawing's impact is due to the artist's imagination is clearly evident when we look at what probably was the artist's source—a small wood engraving published in an 1838 issue of the *Penny Magazine* (fig. 28). Because of the maker's skills in the use of the marble dust medium the small engraving has been transformed into a

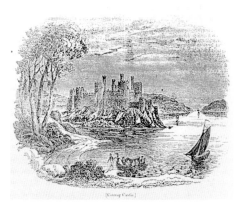

Fig. 28

Conway Castle

Maker unknown

Wood engraving

Published in the Penny
Magazine, *June 30–July 31,
1838*

romantic scene: a medieval castle whose stark white windows, sharply crenelated walls, and bristling forest of soaring watchtowers are silhouetted against the moonlit sky, conjuring up memories of ghostly stories and

Fig. 29
View of Lake Fucino, Italy
Maker unknown
ca. 1860
Charcoal and chalk on
marble dust board
17 1/2 x 22 1/2

Fig. 30a
View of Lake Fucino, Italy
Lithograph published
ca. 1850, in
The Vermont Drawing
Book of Landscapes

dastardly deeds. The strange stagelike lighting effects illuminating the edges of the foliage and shrubbery also add to the drawing's sense of unreality, which the artist intensifies by drawing in white chalk on the dark charcoal surface of the lake a transparent, phantom boat.

An even clearer demonstration of how freely the artists of marble dust paintings interpreted the prints they copied can be seen in a work we originally thought of as an imaginary landscape (fig. 29). From the first moment we saw it we were captivated by its wonderful muted symphony of grays and blacks and its stylish shapes, even though we never could figure out what the scene represented. The pile of objects in the lower right defied identification, and the stick figures and cart in the center seemed to be sinking into some kind of sandy expanse. It was therefore a true shock to discover much later that this odd scene had a specific identity. We found its source in

a drawing exercise book of about 1850, *The Vermont Drawing Book of Landscapes*, compiled and published by the Episcopal bishop of Vermont, John Henry Hopkins, D.D., who occupied that office from 1832 to 1868 (fig. 30a).

There can be no doubt that this lithographed view, identified as Lake Fucino in Italy, was in front of the artist when our work was made. The pyramidal mystery object in the right foreground turned out to be simply a boulder in the original; the wagon had not been swallowed up but only partially obscured; and the foreground figures had been completely filled out and convincingly rendered. Our painting was unmistakably the result of the artist's personal interpretation of this print, its depiction of natural objects like rocks, trees, and figures being replaced by images evoked by the intuitive visual language of the artist.

How deliberate and personal this act was became even more evident to us when a friend called our attention to a pencil drawing (fig. 30b) made by another student after the same illustration in Bishop Hopkins' exercise book. This drawing, in contrast to the marble dust copy (fig. 30c), showed us what a faithful—one could almost say dutiful—copy of the original should look like. As we can see in this detail, each bend of the tree trunks, the massing and details of the leaves, and

Fig. 30b
Detail from anonymous, undated pencil drawing after above plate in The Vermont Drawing Book of Landscapes, *present whereabouts unknown*

Fig. 30c
Detail, fig. 29

each of the foreground rocks and bushes have been precisely repeated. Bishop Hopkins' expectations were, no doubt, more than fulfilled by this meticulous rendering of his example.

Knowing now the printed source for both the marble dust painting and a pencil drawing, we value our own piece even more. It is very clear just

what this artist's formal visual preferences were and, much to our delight, we discovered that just those features were the ones that originally had attracted us to this work. The artist's personal manner is particularly obvious in the way the foliage on the large tree is depicted—as if it were made up of a series of fan-shaped wedges, each with a distinct wavy edge. Another individual approach can be seen on the left where the row of trees is spotlighted as if it were a

Fig. 31
View from Hyde Park
Maker unknown
ca. 1860
Charcoal and chalk on
marble dust board
17 1/4 x 21 1/2

chorus line. Through the maker's eye we see the trees lined up like a row of cut-out sponges. Learning how the artist translated the model from the drawing book into a distinctly personal visual language made this artist a very special one for us, one who from an

exercise book could produce an original landscape of magic shapes and light.

We are attracted to works showing such an idiosyncratic approach and so were particularly delighted by this marble dust painting we call *View from Hyde Park* (fig. 31). Like the other marble dust paintings we have looked at, this work also has its origin in a published print. The engraving includes a promenade of spectators at the right side, but the artist has disregarded this section of the print in favor of the landscape alone. As is easily visible, this artist has a marked preference for rounded forms: the immediate foreground undulates before us, the sails of the boats billow out in curves, and the distant range of mountains becomes as softly rounded as if they were haystacks rather than uplifted rocks. The single most personal example of this artist's vision, however, is the way the large tree on the right has been depicted. Its shape both heightens the impact of all the other rounded forms and makes it into a signally different-looking object. With its branches writhing upward like tentacles, this tree has become more octopuslike than arboreal.

Another aspect of marble dust paintings that amused us, and one that we came to look for, is the potential for diverting the viewer's attention from an artist's limited drawing skills. One of our favorite examples of this

is the oval drawing we call *Italianate Landscape* because of the parasol-shaped pine tree and villa-like buildings in the background (fig. 32). This work is also probably based on a print that provided the general format of the scene as well as its different components. At least it seems unlikely that the round pond and the rectangular pedestal would have originated with the artist, given the problems they obviously posed for depiction. As jarring as these parts of the work appear, they nevertheless do not detract from the overall work sufficiently for us to see it as a failure. What saves the work and gives it a distinctive appearance is the artist's innate sense of the powerful decorative effects that can be achieved in marble dust painting. Probably more intuitively directed than guided by an existing print, the maker chose to emphasize the sharply silhouetted bursts of foliage at the top, the decorative, dense pattern of the bending trees, the fanciful curves of the distant mountains, and the bright reflecting surfaces of the objects on the right-hand side of the painting. All of these elements go together to create an ornamental work of art that could produce a praiseworthy effect on a parlor wall.

Another work also demonstrates how the medium can come to the aid of an amateur artist of limited artistic talents. This view (fig. 33) of the Hudson River Valley seen stretching out before us from Fort Putnam, New York, was a

favorite scene of nineteenth-century painters, whose works were frequently reproduced as prints. Probably working from one of these prints, the artist of this scene emphasized the vast expanse of the landscape by putting down a broad sweep of uniform charcoal powder to create the mottled gray sky and used the marble-textured undercoating to give the river a bright, watery surface. So successful is the artist in re-creating the visual glory of this vista that we overlook the inept handling of the graphic details and are content to join the spectator and his dog to gaze at the tiny, crudely drawn boats in the distance.

In addition to offering amateur artists an art form that lent itself to dramatic and ornamental renderings, marble

Fig. 32

Italianate Landscape

Maker unknown

ca. 1860

Charcoal and chalk on marble dust board

15 x 18

dust paintings were works that could be produced in almost any way the maker chose. If the artist took a personal delight in working in wide swaths of shades using sponges or brushes, or took greater pleasure in picking out details using sharp instruments, the choice was the maker's. Two of our prized pieces show how differently the artists in this medium were able to work (figs. 34, 35). The farm scene (fig. 34) does not immediately suggest derivation from a print, even though certain details, like the houses and the boating scene in the foreground, point to its having followed some preexisting sources as inspiration. What makes this scene

appear at first to be removed from the dramatic light-and-dark composition common to both prints and marble dust paintings is its overall uniform tonality that holds the extremes of light and dark in balance. This is due to the artist's having chosen to treat the marble dust undercoating more or less coequally with the dark applied lines. As a result this marble dust painting looks more like a typical charcoal drawing than do the others.

This artist also added many more white lines over the dark areas as in the dark trunks of the trees whose growth patterns are delineated by white chalk lines. The leaves also have been

Fig. 33

View of the Hudson from Fort Putnam, N.Y.

Maker unknown
ca. 1860
Charcoal and chalk on
"S. J. Woods No. 2
Monochromatic Board"
15 1/2 x 21 1/2

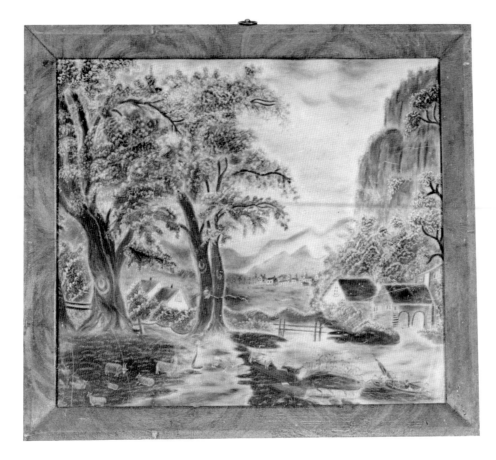

Fig. 34

Farm Scene

Maker unknown

ca. 1850

Charcoal and chalk on

marble dust board

23 x 26

defined by lightening their edges, giving an airy appearance to the foliage. All the objects in the painting have been similarly depicted, and the cumulative effect of this technique gives a modulated shading to the scene, lending it a greater atmospheric quality than is present in the other marble dust paintings. Because of this the trees, grass, houses, and mountains seem more like their counterparts in nature rather than those found in an engraving or lithograph.

The painting entitled *The Enchanted Island* (fig. 35) was probably inspired by a preexisting source, as other marble dust paintings of the same subject exist. The technique of this artist, however, is so delicate that it leads to the work of art becoming a unique piece. Following the method recommended in the manuals, the gray cloudy sky and the mirror surface of the water were the first areas of the marbleized undercoat to be covered over with charcoal. Other sections were left bare or highlighted with white chalk, as in the much brighter area around the island. The light gray

foliage was then worked over to partially expose the white underground, thus adding a flickering, silvery effect to the leaves and grasses. Then, using a pen or needle, the artist

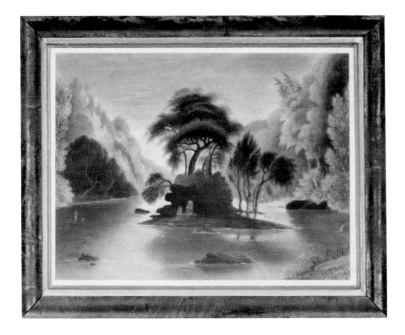

Fig. 35

The Enchanted Island

Maker unknown

ca. 1850

Charcoal and chalk on marble dust board

15 x 20

depicted the gushing fountains on the island, a standing heron, and a spirit figure in a boat. Bathed in ethereal light, this magical landscape derives its sense of mystery from these phantomlike objects. The viewer who gets caught up in its effect comes to believe that the figure gliding across the water is on the way to perform some ancient ritual at the island's spring.

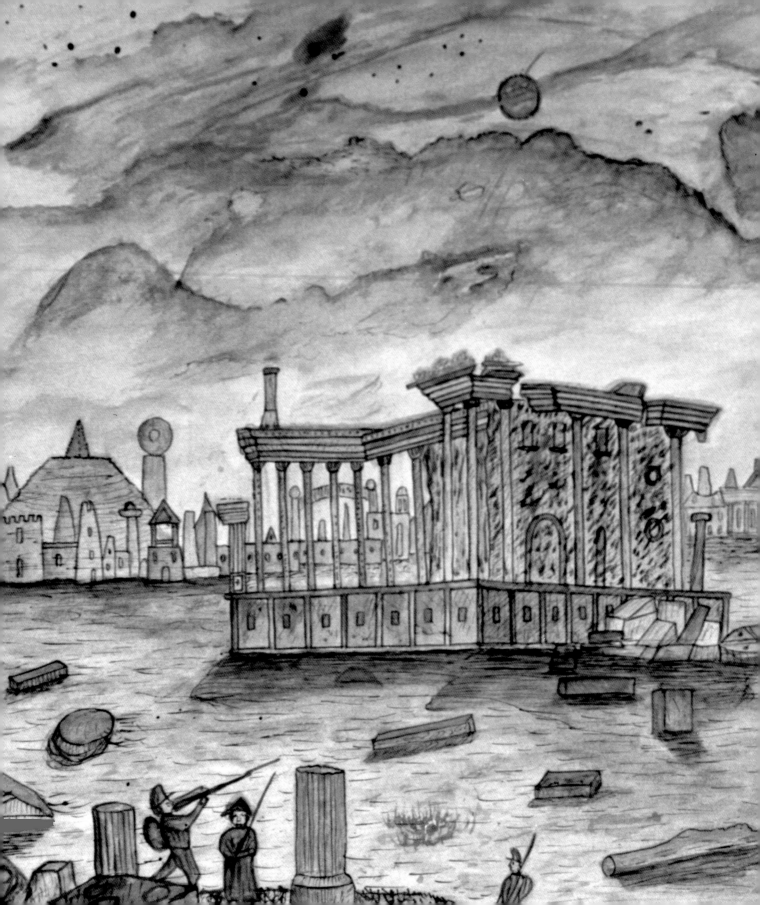

An Unidentified Star

One of the most joyful experiences we have had as collectors was acquiring a number of watercolor masterpieces by an amazing nineteenth-century artist about whom, unhappily, almost nothing is known except a name. That is truly regrettable because these drawings are so imaginative they must be the product of an exceptional mind and an equally sensitive eye. If it ever could be said that we had discovered a Leonardo in our search, this artist would be the one.

Our lack of knowledge is frustrating because there are so many unanswerable questions concerning the drawings. They were first discovered in the mid 1930s as part of a bundle of some 250 drawings. Most of them were on the same size and type of paper, and many were pasted together to form strips about thirty feet long containing groups of individual but interrelated scenes. Among the subjects depicted were historical events, geographic and architectural views, biblical scenes, moralistic parables, and disasters like fires and shipwrecks.

The fact that some of the drawings were found together as scrolls encouraged the idea that the scenes were made to be displayed in sequence to audiences. Although such panoramas, as they were known, did exist in the nineteenth century, the physical evidence from these particular drawings does not suggest that they were ever used in this fashion.

Aside from these physical and observable facts, no specific evidence about the creation of these works is known. One smaller drawing entitled *The Utica Academy Building* seems to lend credibility to an otherwise unsubstantiated story that all these drawings were made by students under the direction of an art teacher at an academy in Utica, New York. The fact that the quality and style of the drawings are so varied supports the belief that they are probably the work of several artists. Currently, however, all of the drawings are simply attributed to the "Utica Master."

There is evidence, however, for the identification of one of the artists: L. W. Ladd. His signature appears on the scene of Adam and Eve in our collection (fig. 36) and on an additional watercolor in another collection. Four other watercolors were once labeled on the back as being the works of a "boy named Ladd from Utica, New York, 1876." Another drawing has two cipher inscriptions, one of which has been interpreted as reading "Lawrence W. Ladd" and gives him the title "Doctor," whereas the other cipher reads "Ilseph Buck" with the title of "Artist." No other reference to Buck seems to exist but the information on this drawing confuses the role of Ladd. The evidence of authorship disclosed on the drawings themselves is therefore very scanty, particularly if the estimate is correct that there were originally 250

drawings in the group now described as by the Utica Master.

We are convinced of only one fact—all nine of the drawings in our collection are by the same hand and one of these bears the signature of Ladd (fig. 36).

One of our Utica drawings (fig. 37) appears at first to be the Rosetta Stone that could decipher the mystery of this group. It resembles an introductory title page intended to precede one section of an entire collection of drawings centered on a specific

flats, the artist seems to suggest that each of the drawings was intended to be seen as a separate, dramatic tableau. The announcer (is it the artist himself?) is seated before a curtain which, one hopes, will be parted to reveal why all these drawings have been made. But the curtain never opens, and the peculiar props he has surrounded himself with—the broken column, the model locomotive—and his Irish garb only add to the mystery of what this group of drawings was actually intended to convey.

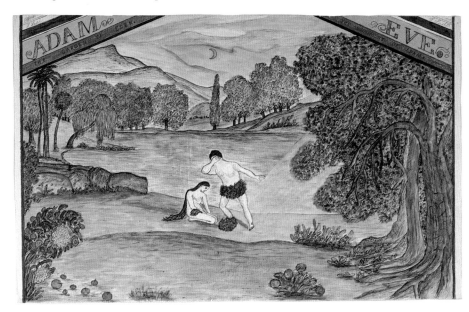

Fig. 36
Adam and Eve
Utica Master
ca. 1880
Watercolor on paper
17 1/2 x 28 1/2

theme. And what an ambitious plan it suggests: *Historical Scenes of the United States*, further described as being the third part of a second section! By placing the title in a theatrical setting complete with stage, footlights, proscenium arch, and wing

Regardless of the lack of information about the drawings, the pleasure and admiration aroused by their quality cannot be lessened. One of the principal reasons these drawings are superlative is the artist's assured use of watercolor. His control and familiarity

Fig. 37
"Historical Scenes of the United States / Section Two, Part Three."
Utica Master
ca. 1880
Watercolor on paper
17 3/4 x 14 3/8

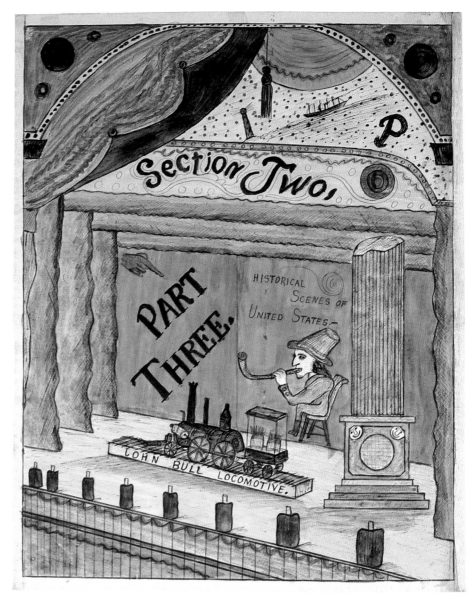

with the medium can be seen in both the enormous range of hues and shades he employs, extending far beyond the palette of the most accomplished watercolorists, and in the degree of contrasts he introduces between dense, even opaque areas and shimmering translucent washes. His incredible, probably intuitive, feel for the possibilities of this medium seems to echo the superlative sense of color shown by the medieval creators of the astonishing stained-glass windows of the cathedrals.

The sensitive selection of hues and the rich chromatic effect created by their juxtaposition is particularly evident in the artist's view of a cave's interior (fig. 38). Here the colors are made richer and more vibrant by an exuberant crosshatching, while others gleam and shine because they are surrounded by areas of neutral gray or brown. The way color is used to give a special aura to the subject is different in each of our drawings. The drawing closest in its use of color to that of the interior of the cave is the view of the cathedral (fig.

medium is apparent in the dramatic representation of Adam and Eve (fig. 36). In the upper corners of the drawing the artist has emblazoned the title across a colored proscenium arch enclosing the scene. This device immediately creates a theatrical setting, placing the principal figures on a stage surrounded by a landscape of varied, arboreal, green shapes seen across a blue body of water. In each of these areas the color seems to float across the surrounding landscape as if it were shielding the background from our

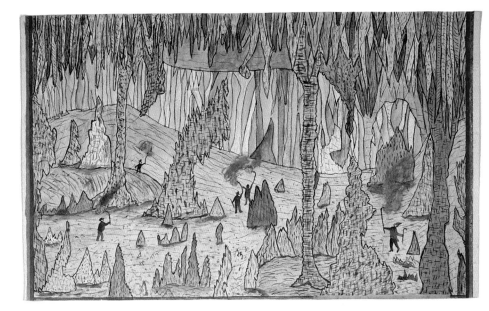

Fig. 38
A Speleological Expedition
Utica Master
ca. 1880
Watercolor on paper
17 1/2 x 29 1/4

39), where the foreground and sky are each colored uniformly, thereby intensifying the vivid colors used to depict the building itself.

A different use of color and of the qualities inherent in the watercolor

direct sight. The entire scene becomes distinctly theatrical, as if enacted before a painted scrim.

In the preceding works the artist's use of color depends upon subtle isolation and combination of hues. Other works,

Fig. 39
***An Unorthodox
Cathedral***
Utica Master
ca. 1880
Watercolor on paper
17 1/2 x 29 1/2

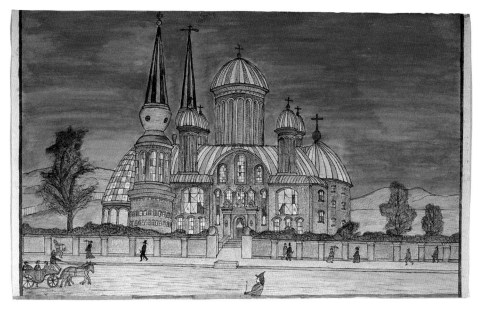

however, introduce a magic blending of color washes that vie with effects seen only when certain kinds of clouds and sunlight come together. Just such a sky is the one he depicts above the vast expanse of classical ruins at Palmyra (fig. 42).

In all of these watercolors the artist shows a heightened familiarity with the delineating power and emotional effect of great sweeps of solid color and, in particular, demonstrates an awareness of how combining them can produce powerful results. Such control over the art of watercolor is an amazing talent but, surprisingly, it is not equaled by this artist's drawing ability.

Although noticeable in many parts of the drawings, this dichotomy is particularly evident when he attempts to draw the human figure. He does not

shy from this task, indeed he even seems to enjoy it, as he populates his drawings with figures rowing boats, flourishing canes, or aiming rifles. He makes almost no attempt to depict their bodies through shading or foreshortening but relies on their actions or poses to convince us of their reality. His lack of drawing skill is also observable by the way all the inanimate objects—whether geological, botanical, or architectural—are defined by heavy, dark outlines. These serve both to enforce the shapes of the objects and to act as boundaries for the areas of color. As we have seen, this way of drawing is found in works by both children and their unschooled elders, but in this case the artist's other abilities are so superior that his watercolors seem to be the product of a more knowing hand.

This observation is also borne out by the astounding originality the artist shows in the choice and presentation of his subjects. Our drawings were apparently not made by copying illustrations from books or periodicals, although the bulk of the others in the Utica Master group can be traced back to specific prototypes. In fact, some of these other drawings conform so closely to the works they were copied from that even the drawing style is the same. We have not found, however, any earlier illustrated sources for our

written word is astonishing. We are left with a sense of wonder and amazement at the achievement brought about by the conspiracy of his mind and his eye.

One of the most direct examples of textual interpretation is his presentation of Adam and Eve (fig. 36). Unlike more traditional representations that show Adam and Eve naked, standing before an apple tree entwined by a snake, our artist has painted the figures of Adam and Eve after this moment. He depicts

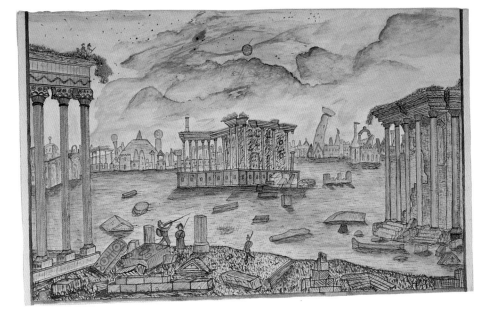

Fig. 40
Bird's-Eye View of Rome
Utica Master
ca. 1880
Watercolor on paper
17 1/2 x 28 1/2

drawings, although one, *Bird's-Eye View of Rome* (fig. 40), almost seems to demand a printed source. We must conclude, therefore, that he worked only from literary descriptions or textual information. His ability to create visual images solely on the basis of the

them conscious of their bodies and aware of their shame. The act of temptation is referred to only by the scattered apples in the foreground. In the artist's staging, Eve casts her eyes down and Adam shields his eyes from the spectral light streaming from the

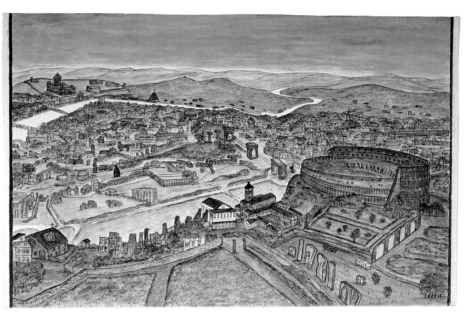

Fig. 41
London Bridge in Elizabethan Times
Utica Master
ca. 1880
Watercolor on paper
18 x 29 3/8

upper right and carrying the message of banishment from the idyllic landscape of the Garden of Eden. Adam and Eve appear as helpless and guilty as the biblical story portrays them.

The drawing of Adam and Eve shows us the artist creating a tableau, while his view of *London Bridge in Elizabethan Times* is given a more dramatic context by the inclusion of a rescue scene (fig. 41). It is unlikely that he used a prior illustration of this scene even though a rare sixteenth-century print of the bridge exists. The artist's depiction of a drowning man lends testimony to his ability to visualize an event solely from a verbal description, for textual accounts make specific mention of drownings that took place here because of the treacherous currents near the bridge.

Everything that speaks to us in this drawing is a triumph of the artist's imagination over his limited drawing ability. The rescue conveys both the strength of the water's current and the fragility of those opposing it. The heads of criminals seen on the bundles of stickpinlike spikes are treated as casually as they appear in written descriptions, a macabre decoration to the turreted, fancifully narrow tenements that crowd the bridge.

A further affirmation of this artist's powers of visualization can be seen in the bird's-eye view of Rome (fig. 40). His depiction of the city in this manner is highly unusual, as if he had benefited from a balloon ascension. Unlike many popular contemporaneous printed views of Rome, this drawing has more in

44

common with much earlier representations of the Imperial City— even to ones made several centuries before. His presentation, like the earlier views, emphasizes the Tiber River as a key element in the definition of the city, tracing its path across the landscape in opaque white paint. Similarly the church of St. Peter's, and particularly its dome (seen at the top left), is depicted in the same way that domed buildings were drawn in the late fifteenth and early sixteenth centuries. Despite these anachronistic elements and regardless of the artist's almost humorous handling of some of the monuments—the broken arches of the aqueduct which parade across the foreground look more like pieces of toast than masonry remains—the view he has imagined is correct in its basic orientation and in the location of its principal monuments. Our fascination with this artist grows with this demonstration of his perceptive powers, although we remain incapable of genuine explanation.

In the view of the *"Ruins of Palmyra"* (as it is inscribed on the reverse) we encounter yet another dimension of his imagination (fig. 42). In the previous drawings, no matter how personal and inventive his images, his renditions of the scene can be validated by some type of description. In this case, however, he had few sources to rely upon. The vast remains of the Roman desert city of Palmyra were poorly described and illustrated at this time.

Textual references to the classical site generally spoke of it as simply being a great jumble of architectural ruins. Although illustrations of the site had been published in the eighteenth century, they were very rare and unlikely to have been available to him. Thus the delineator of this scene had to rely almost solely upon his imagination to portray the ruined temples and colonnades of Palmyra.

How slight his knowledge must have been is made immediately apparent by the watery expanse he has placed in

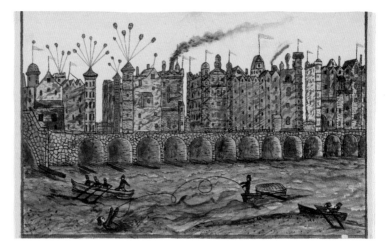

what should be a desert setting. The architectural forms are equally idiosyncratic. Apparently he felt completely free to fantasize, and he did so in such a whimsical way that it seems clear his knowledge of classical architecture was restricted to textual references rather than to illustrations. His columns, impossibly tall and thin, are topped with capitals which look

Fig. 42
"Ruins of Palmyra"
Utica Master
ca. 1880
Watercolor on paper
17 1/2 x 29

more like nougat candy or dominoes than acanthus leaves. He was master of his own classical architecture and his fancy also took him well beyond the past into the future. For he makes the distant skyline into an amazing group of architectural and sculptural forms that are ultimately realized only in some of the casinos in Las Vegas or in the work of Claes Oldenburg.

Nor did the artist confine his imagination to creating his own style of classical architecture. As we can see in the drawing we have called *An Unorthodox Cathedral*, he also freely ventured into a Byzantine mode (fig. 39). But his manner of combining such elements as a central dome, apsidal endings, towers, lanterns, and stained-glass windows makes this building very much his own. We might even imagine that his style here seems to be coming more from a baking oven than a drafting board. For us, his building looks like a gingerbread construction, elaborately decorated in different-colored frostings. Of course, if we take into account that the passersby in front of the building seem to be oblivious to the monument's existence, we may, indeed, be seeing only a mirage of a cathedral.

When his attention turns to geological rather than architectural formations, the artist's imagination truly soars. The drawing of a cave's interior (fig. 38) depicts no identifiable underground site but more likely results from his

having read about the wonders of several different caves. What he has created seems the epitome of what a cave should look like: stalactites and stalagmites making mysterious forms that fill an immense hollow space, strange shapes rising from the ground like flames, others dripping like a fringe from the roof—all in vividly glowing colors. Visitors wander about in awe with their torches lighting up this forest of fanciful forms. Visiting an actual cave might have been anticlimactic after seeing this.

Someday a historian may be able to discover more about this great trove of folk art drawings. Perhaps the different hands that made them will be sorted out and their differing qualities evaluated. When that is done we are confident that singled out from the entire group will be the maker of our drawings—one whose creative imagination makes him a truly original star among our country's naive artists.

(The information given here about the Utica Master was gathered in an interview in 1976 with Peter Tillou, who purchased all the drawings as a lot in 1973, and from the catalogue written by Paul D. Schweizer, director, and Barbara C. Polowy for the exhibition Panoramas for the People *held in 1984 at the Munson-Williams-Procter Institute in Utica, New York.)*

Cutting, Piecing, and Sewing

Anyone looking for objects produced in America from the eighteenth to the twentieth centuries will encounter an overwhelming number of articles made from textiles. Creating quilts, bedcovers, table covers, and wall hangings was an important part of daily life; not only were these items practical, but making them was deemed a commendable pursuit. Their presence in a household indicated that neither idle fingers nor daydreams were tolerated. Only a few of these objects, however, are visually exciting and even fewer speak with a distinctive voice that reveals the personality of its maker. What produces such singular works is hard to tell. Sometimes it seems to be the inspiration of the type of fabric used,

at other times simply an economy of means dictated by the necessity of using material of certain shapes or sizes. Almost always, however, it comes about because in creating the work the maker has turned away from a traditional model.

Given our preference for works with a strong sense of personality, we were not lured by the beauty of traditional quilts, even ones that might bear the names of their makers. Often the pattern of such quilts was not original to the maker, and quality was frequently linked more to technical mastery of the quilting than to the quality of its graphic design. Also, fancy quilting was often the product of a group rather than a single individual. Because technique is not what fascinates us, we also were not drawn to examples of fine crewelwork, samplers, or, with one exception, needlepoint. We perceived these to be works of expertise alone rather than objects of bold, personal expression.

Our preference was for objects like the bedcover we have come to call *An Exploding Universe* (fig. 43). This hefty and even somewhat clumsy example of needlecraft impressed us as an artistic statement because of its forceful design and equally powerful palette. Its maker clearly went beyond the traditional, elegant Bethlehem Star pattern, whose rays are kept tamely within the boundaries of the quilt. Here, instead, flashes of color leap into

Fig. 43

An Exploding Universe

Maker unknown

ca. 1880

Scraps of various fabrics,

printed cotton backing,

wool yarn tufts

84 x 84

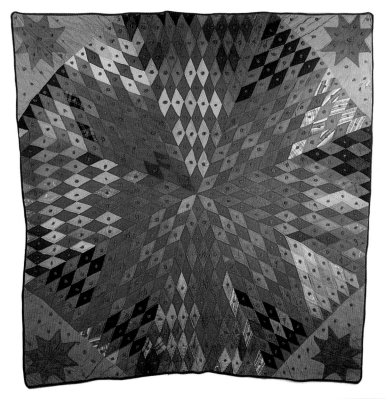

motion in a giant red pinwheel whirling about in an emerging and dissolving pattern created by the multitude of different-colored diamond shapes. One is tempted to say this maker wanted to make a big bang of a statement and did!

A work of comparable nature is the bedcover (fig. 44) made up of a chaotic mass of multitextured pieces of suiting haphazardly stitched together. This design appears at first to exist outside the formal constraints imposed by a traditional quilt pattern, but it probably is related, if only distantly, to the optically deceptive quilt pattern known as Tumbling Blocks. This bedcover seems to reflect the joy and enthusiasm its maker felt when cutting out and fitting together the irregular pieces. Intuitively arranging these odd shapes into some kind of organic grouping was a challenge this maker met through a sensitive eye and a willingness to be original.

Each of the preceding works follows, in its own way, a standard quilt form. This is also true for the bedcover (fig. 45) whose underlying composition derives from a pattern known as Streak of Lightning. We call it *The Passing Storm* since its maker seems to send a larger message. Its distinctive and unique character is derived both from the use of corduroy, whose texture gives a greater depth to the colors, and from the way these pieces are sewn together to form larger areas of light and dark. The maker appears to be trying to turn

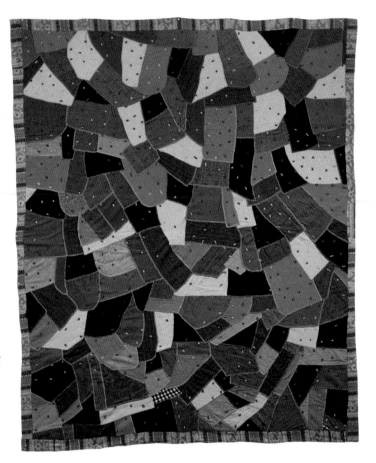

the formal design of diagonal rows of alternating color into an image of a sky filled with dark clouds whose edges are momentarily and brilliantly illuminated by flashes of lightning. In this way a standard formal quilt pattern is transformed into a scene of incredible energy and force; the pattern of diagonal stripes shifts from being an abstract design to one suggesting the energy of a storm.

A different kind of visual stimulation led us to appreciate the large wall hanging that exists solely in an abstract world of

Fig. 44

Tumbling Boulders

Maker unknown

ca. 1915

Wool suiting pieces backed and edged with block printed cotton fabric, wool yarn tufts

68 x 23

Fig. 45
The Passing Storm
Maker unknown
ca. 1930
Cotton corduroy,
cotton edging and backing
69 x 72

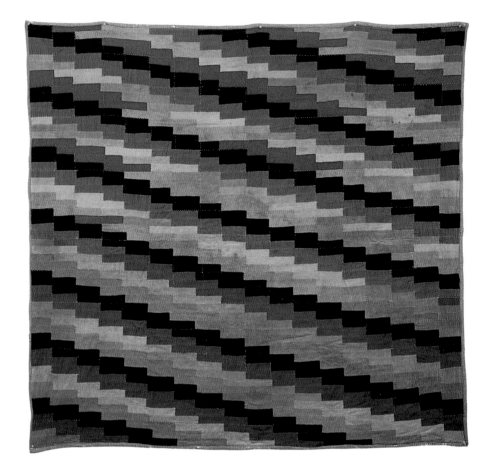

Fig. 46
Floating Circles
Maker unknown
ca. 1935
Felt
40 x 64

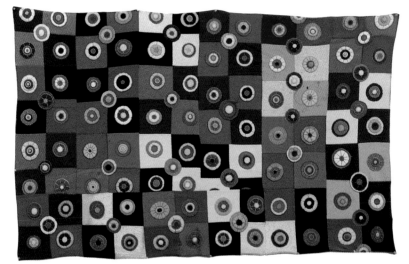

color and shapes (fig. 46). Said to be of Amish origin, it presents a random sequence of clashing areas of color and spinning shapes that never come to rest. Although its effect reminds us of a painting by Kandinsky or Delaunay, it is unlikely the maker was familiar with their work. Its design, which we call *Floating Circles*, appears to result from an original and spontaneous joining of wildly colored blocks and circles into rows that do not exactly meet the pattern of either adjacent row. The restless and strident impression of this visual statement is not unlike a jazz

piece where an underlying mesh of harmony provides the setting against which individual performers and instruments can be admired.

Unlike our other fabric objects, which are composed of many small pieces sewn together, *A Fast Trotter* (fig. 47) is made up of only a few large pieces applied to a backing. This choice— probably intuitive—gives it a childlike quality that increases its visual impact. Actually, closer examination discloses a skillful hand and educated eye. Although the continuous cookie-cutter outline of the horse seems innocent at first, the selection of bright thread and bold zigzag stitches giving motion to the shape suggests a sophisticated maker. Equally clever is the way the dark

horizontal bands are placed behind the horse, not only suggesting a fence but also giving a strongly defined and static mode to the entire background, thus playing up the friskiness of the colt.

Fig. 47
A Fast Trotter
Maker unknown
1940s
Wool suiting pieces
25 x 36

Fig. 48
Four Birds in My Garden
Maker unknown, said to be
from Vermont
ca. 1865
Wool and cotton sewn on
linen backing
24 1/2 x 34 1/2

Fig. 49

A Victorian Vocabulary

Makers "Ada" and "Edith"

Dated "1881" (top) and

"1889" (bottom)

Wool needlepoint

24 x 24

A more elegant piece of appliqué work is the exceptional penny rug we call *Four Birds in My Garden* (fig. 48). By comparing this piece with the penny rugs shown in the first chapter, we can see that this maker has aspired to a grander level of beauty. Rather than using the circular motifs to completely cover the cloth, the artist has transformed them into festive accompaniments to four graceful blackbirds flying toward a stylized fruit tree. A densely packed mass of boldly stitched colorful circles covers the ground, giving the composition a richly layered, dynamic context for its subjects. Surely this gifted maker must have received many compliments on

this work from friends and relatives, who no doubt also remarked on the luxurious brocade fabric used for the corner birds.

Our enthusiasm for objects with a distinctive individual character was tested by a piece of Victorian needlework (fig. 49) which apparently is the creation of two makers. The names "Ada" and "Edith" appear in the work as do the dates "1881" and "1889." Although these facts may suggest unusual circumstances in its making, this piece appealed to us for a different reason. We were struck by the way these two makers brought together so many different decorative motifs that their work becomes a kind of pattern book of subjects frequently found in late nineteenth-century needlework. Although other similar pieces combining such motifs do exist, they more often set each example carefully apart, almost like photographs mounted on an album page. Ada and Edith, however, chose to imitate in needlepoint the paper collages they and their contemporaries loved making. The sudden flood at this time of inexpensive colored illustrations allowed women like Ada and Edith to freely juxtapose subjects and objects from different worlds to create scenes of fantasy, foretelling the collages of Max Ernst and his followers. This piece also shares that collage imagery, blending together different subjects to constitute a series of "now you see it, now you don't" images of vastly different scales set

against a wonderfully dense and shadowy background.

Hooked rugs were probably the most common handmade object in American homes for almost a century after 1850, when the burlap sacking used for backing the rugs became readily available. Soon thereafter printed patterns on the burlap backing began to be produced commercially, and by the 1890s the big mail-order houses, such as Sears and Wards, were distributing both patterns and hooking tools. Rug-hooking was apparently a craft most commonly practiced in rural

Because of the wide use of patterns, hooked rugs usually can be judged only by the technical accomplishments displayed. Occasionally they can be admired also for the way their makers added to, and improvised upon, the printed patterns. Other makers completely rejected the use of patterns and made their own designs; these were the hooked rugs that sparked our interest whenever we were fortunate enough to find them.

The rug representing the King of Beasts (fig. 50) illustrates an instance in which the maker seems to have created an

Fig. 50
Ferdinand the Lion
Maker unknown, said to be
from Vermont
ca. 1890
Cotton fabric hooked
on burlap
21 1/2 x 43

America during the nineteenth century, as none of the how-to-do-it books or periodicals gave instructions on making rugs. Nor was it a subject taught at female academies, where fine needlework and embroidery were the sewing counterparts to pencil drawing and marble dust painting.

original design. Lions shown as tame beasts in luxuriant settings were one of the most popular subjects in commercial patterns, but unlike the lion of this rug they rarely possessed a personality. In contrast, the lion seen here seems to display distinct traits of character. Indeed, we have even come to believe

with the startling blasts of color within the otherwise soft and harmonious shades of brown and gray. The tree shaped as a single orange leaf, the raspberry fence, and the vine's pink flowers create a staccato rhythm that is repeated—although in a more metallic beat—by the jagged black edges of the lion's mane. Both of these visual traits—the bright colors and broken lines—lend a distinct personality to the lion, whose playful character makes us ready to accept the idea that he actually ate the flowers.

A hooked rug could become a lively work of art in the hands of someone gifted with a sense of color and shape as well as a sense of humor. This is evident in the rug we discovered in Vermont and call *The Pampered Pet* (fig. 51). Here, a wonderfully calm color scheme and a subtle design transpose a banal canine motif into a portrait of a much-beloved household pet. This transformation is effected by a series of borders of varying widths and colors which enclose a central area of alternating bands of light and dark. Within this confined space, the dog shape assumes a lifelike presence, and we can imagine him as a pampered pet, dressed in a rose-colored coat and a big blue bow, patiently posing to be immortalized.

Another maker took a very different approach when portraying the family pet (fig. 52). We were immediately struck by the maker's boldness in

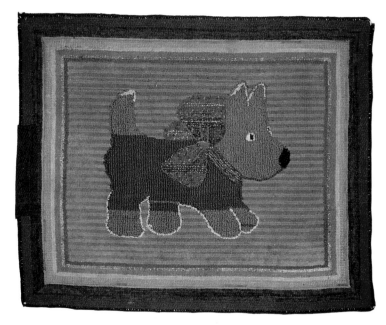

Fig. 51
The Pampered Pet
Maker unknown
ca. 1930
Rag and yarn hooked
on burlap
27 x 33 1/2

he must be related to the hero of the classic children's story of Ferdinand the Bull, who delighted in eating flowers. Our hero must also have shared such a taste, giving up the carnivorous appetite appropriate to lions. How else can we understand why the plants around him are missing their blossoms?

This detail escaped us when we first saw the rug because we were so taken

Fig. 52
An Alert and
Suspicious Cat
Maker unknown, said to be
from Indiana
ca. 1885
Cotton fabric hooked
on burlap
22 x 29

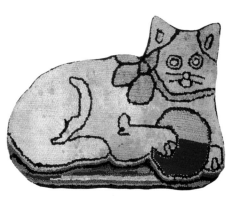

abandoning the traditional rectangular format of the hooked rug for an outline determined by its subject—a cat with a ball on a rug. The limited range of subtle colors gives weight to the body; the simple, descriptive lines endow this cat with a definite personality. The visual devices used to animate the cat account, however, for only part of our enjoyment. Giving the reclining cat a ball to grasp in its front paws energizes the animal with a muscular tension and alertness, which in turn make us conscious of how intently the cat is staring at us.

of copying an object of beauty from the natural world while creating a work of fantasy. Although its shape conforms to the graceful outline of the model inspiring it, the pattern of colors is solely the product of a free, soaring imagination. The wavy edges of the border, shimmering tonal fields, and bright fireflylike center cannot be found in any lepidopterist's catalogue.

When we first saw the next rug (fig. 54) we were arrested by the strong contrast between the swirling, multicolored areas and the intense

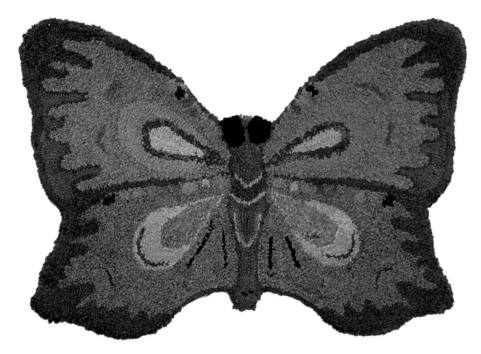

Fig. 53
A Natural Beauty
Maker unknown, said to be
from Indiana
ca. 1900
Various fabrics hooked
on burlap
24 x 36

Like the previous maker, the artist who created *A Natural Beauty* (fig. 53) also departed from the normal form of a hooked rug. This rug's primary attraction lies in the maker's challenge

black of the border and horse. Our initial impression of this piece, which we have called *The Frightened Horse*, has never changed. Subsequently, however, we have come to appreciate

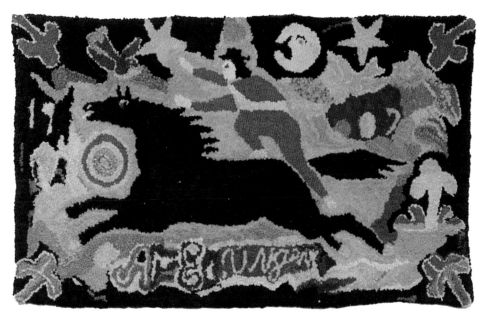

how its maker advanced beyond the natural limits of the medium to freely "paint" with wool.

The maker has created something very rare in a hooked rug—a narrative. The artist, A. E. Ringer, portrays a dramatic incident in a marvelously confident, graphic manner. Each element that describes the scene sacrifices all to action: stars flash, birds flee, the moon grimaces, the trees and ground swirl around the center. Everything worked into this design heightens the drama of the boy grabbing the mane of the animal to halt its flight. We will never know the outcome of this incident—we have only a spotlighted view of a scene which the maker abandons to our imagination, leaving only a hastily scrawled signature.

EUGENE B STEERE.

Twice upon a Time

Recycling is not just a modern phenomenon. American artists and artisans have long been using discarded items as the raw material for decorative and expressive objects. Appealing to a morality of thrift or to what has been called Yankee ingenuity, this approach has produced a wide variety of original products, ranging from bedcovers made from scraps of used clothing to entire houses made from rolled-up newspapers.

Whether creating full-scale environmental works or making smaller recycled objects, all of these artists delight in demonstrating a virtuosity in transforming one kind of object into another. It was this spirit that enticed us into looking for works of this

kind. Although we did not covet birdhouses made from Clorox bottles or flowers made from plastic six-pack holders, we always delighted in seeing these bits of evidence of a particular American craft.

Our attention was directed more toward objects like the small jug which caught our eye in a Providence, Rhode Island, secondhand store (fig. 55). Made by pressing broken pieces of china, glassware, buttons, miniature toys, or dolls into wet concrete or plaster coating an object such as a bottle, jug, or umbrella stand, this ornamental art form was very popular during the early part of this century. We learned that smaller objects like this jug are often called memory pieces, on the assumption that the maker put personal, sentimental souvenirs into the work. These pieces have no preconceived design; the surface pattern simply emerges beneath the hands of its maker as different things are combined from the "palette" of found objects. The appeal of a work like this comes from its spontaneity and its dazzling and colorful array of seemingly unrelated objects.

A different creative approach was followed when it came to reemploying the many artifacts resulting from the use of tobacco. Empty cigar boxes spawned a whole range of handmade objects from about 1850 to 1930 because federal regulations forbade

Fig. 55
Memory Jug
Maker unknown
ca. 1925
Stoneware jug covered
with plaster, inlaid with
various objects
12 x 3 x 3

their reuse after the cigars had been sold. In discarding these wooden boxes, tobacconists provided a bonanza of free material. Most commonly the cigar boxes were broken down into flat pieces of wood which became the raw material out of which other articles were created.

By whittling and layering this raw material, the makers created new objects ranging from large pieces of furniture to small picture frames and decorative boxes like the ones we came upon at a Boston flea market (figs. 56, 57). They were the first examples we had ever seen of a form we later learned was called tramp art (so called because of a misconception that all such pieces had been made by hobos in exchange for food). They have remained our favorite examples of such work even though later we found larger, more ornate pieces. None of these other works, however, surpasses the way in which this maker made superb sculptural forms out of the thin, flat pieces of cigar boxes.

The orange box (fig. 56) rises from a pyramidal base into a series of interlocking planes that form a complex geometric shape capped by the pyramidal form of the lid. Its basic simplicity and sense of solidity make it a quintessential tramp art creation. The gold box (fig. 57) is an even greater tour de force. Here the maker piled up the flat pieces of wood into triangular pyramids of different sizes, creating

the impression that the sides of the box swell out as if made from some pliable material. This effect is further amplified by the gilt paint which makes the notched edges shimmer in the light.

Both of these boxes had to be carefully conceived and thought out before their maker began cutting, notching, and layering the rectangles of cigar-box wood. The stamped names still legible on the bottoms of the boxes tell us that the orange one originally held cigars

Fig. 56

Orange Tramp Art Box

Maker unknown

Early 20th century

Wood from cigar boxes,
painted

7 x 6 x 5 1/2

named "Palma Regina," while the gold box held "American Beauties." In both instances, these very simple but elegant boxes carry on the proud names of their predecessors.

Another small example of tramp art is the picture frame which we treasure because its maker approaches the medium in an uncommon way (fig. 58). Rather than piling up the thin pieces of wood to create three-dimensional objects, this maker uses their flatness to form distinctively outlined shapes, much like cutting cookies from a flattened piece of dough. The notched edges of the wood emphasize their distinctive shapes. Attached to the broad flat planes of the frame, these smaller units are arranged into a pattern of repeated parts, but not to such a degree that the design appears static. Indeed, the contrast between the random and repeated groupings only emphasizes the implied movements of the shapes, as if they were being seen through the lens of a microscope or as they might freely behave in a painting by Kandinsky.

The packaging of cigars provided another reusable article in the form of "cigar silks," the ribbons once used to tie together and identify bunches of loose cigars. Popular before the day of individual cigar labels and boxes, these silks are depicted carved around the cigars held aloft by the wooden Indians that proudly stood in front of cigar stores. Other reminders of their once-useful role exist because wives and daughters saved these cigar silks until they had enough to sew into cleverly designed pillowcases, or even into such ambitious projects as bedcovers, curtains, or table covers. They made splendid ornamental pieces of vibrant colors, and some attained a level of personal expression. The piece in our collection achieves this by its selective arrangement of

Fig. 57
Gold Tramp Art Box
Maker unknown
Early 20th century
Wood from cigar boxes,
painted
6 1/2 x 7 x 6

Fig. 58
Tramp Art Frame
Maker unknown
Early 20th century
Wood from cigar boxes,
painted
8 x 5

60

ribbons, mostly of yellow and gold, punctuated by a few contrasting colors (fig. 59). Its maker also carefully balanced the areas of lettering on the ribbons and used elaborate black featherstitching to hold them together. Finally, this maker put a personal mark on the formal design by adding an exuberant border of freely hanging silks and tassels.

Another by-product of the smoking habit was the wooden match used to

light up. Usually thrown away by their users, some were saved for surface decoration on boxes, table tops, and smoking stands. In some cases, the matches used for this purpose were not actually struck to light a cigarette but were purposefully singed to create decorative material. One of the most inventive uses of such matches that we have seen is the picture frame included here (fig. 60). These singed matches are not applied to a surface but are grouped together in the form of

Fig. 59
A Golden Hanging
Maker unknown
ca. 1890
Silk cigar ribbons, silk backing
44 1/2 x 43

rays that give the appearance of having been carved out of a solid piece of wood. The resulting effect is a bold and active design radiating out from the object it was intended to enframe.

Fig. 60
Matchstick Frame
Maker unknown
1930s
Singed wooden matchsticks
13 x 9

Fig. 61
Bottle Cap Basket
Maker unknown
1940s
Painted metal bottle caps
8 x 7 x 7

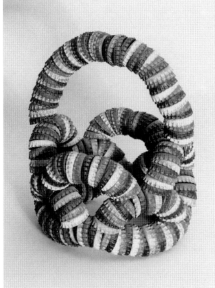

The soft drink industry also provided a stimulus to would-be users of discarded material such as soda bottles, from which houses in the western desert were sometimes made, and tab openers of soda and beer cans, used today to make jewelry. During most of the twentieth century, however, the plentiful bottle cap was one of America's favorite recyclables. Commonly nailed to all types of objects to give them a rough, textured, metallic surface, the caps also were strung together into chains of different lengths. Some makers felt challenged to string longer and longer chains of bottle caps, which became known as bottle cap "snakes." Other makers painted the caps in bright colors and strung them together in smaller chains, which they then twisted into various shapes. The small basket we favored (fig. 61) exhibits within its sinuous curves almost all of the expressive qualities of this medium.

Of all the objects made from recycled items, one type we had especially hoped to find was a collage made from postage stamps. Perhaps our desire was due to sentimental reasons, since both of us remembered grade-school experiences of pasting down canceled stamps to make fanciful designs. In fact, Isabel still has one—a Valentine heart made out of the red two-cent Washington stamps common in our childhood. The primary reason for our search, however, was that because canceled stamps exhibit such a

62

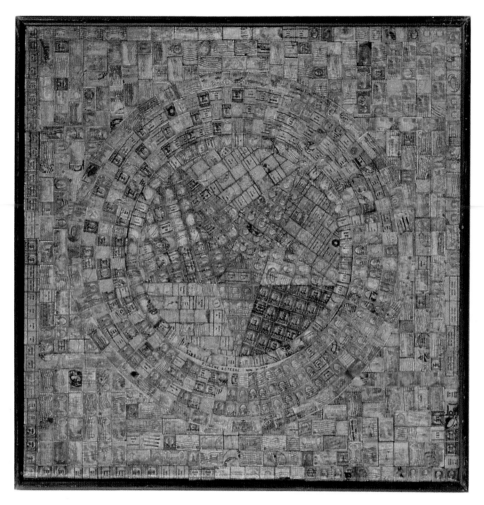

Fig. 62
A Prophetic Piece
*Signed and dated lower
center "Eugene B. Steere /
Aug. 31, 1938"
Canceled U.S. postage
stamps applied to top of
card table
28 1/2 x 28 1/2*

marvelous range of color and texture, objects made from them can have exceptionally beautiful surfaces.

Alas, over the years the stamp collages we turned up were usually small postcards from pre-1937 China with meticulously cut and pasted stamps showing pigtailed figures being pulled in rickshaws. The only American pieces to emerge were maps of the United States with each state formed by using stamps canceled in that locale,

but these seem to have been created more from a philatelic interest than a creative urge. So imagine our surprise and delight in discovering a magnificent example (fig. 62) at a Virginia shop otherwise filled with English furniture. We rescued it from its foreign surroundings and became the owners of the largest work of its kind we have ever seen.

The artist, Eugene B. Steere, used a standing wooden card table for his

"canvas." He pasted stamps over the entire surface of the tabletop, using their color and texture to "paint" an overall geometric composition. Since he apparently had an inexhaustible supply of stamps, he was able to use ones of the same hue to create differently shaped blocks of color to form the central star and to encircle it with decorative patterned rings. The remainder of the square top he filled with a looser, more varied arrangement of different-colored stamps. What emerged is a glowing design that anticipates the paintings of Jasper Johns by its form, color, and texture. But this piece is firmly set in its own time, for if one leans closely to the card table one may still hear the sounds of the 1930s radio programs Mr. Steere listened to as he arranged and pasted down his stamps.

Capturing the Essence

A true challenge for an artist is to capture a subject's essential nature by its outline alone, while at the same time giving that defining shape a special quality of its own as a compelling decorative object. The maker of the rooster weathervane accomplished this

Fig. 63
Rooster Weathervane
Maker unknown, said to be
from Vermont
ca. 1910
Painted sheet metal
22 x 16

Fig. 64
Mythical Beast
Maker unknown, said to be
from Virginia
1940s
Painted sheet metal
11 x 17

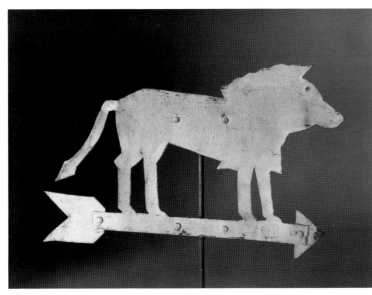

with ease and élan (fig. 63). Although cut out of metal, the body of the cock is so elegant it could have been cut out of paper by a silhouette maker. The swelling, curved outline of the entire piece is barely disturbed by a few cuts into the tail and a minimal description of comb and beak. Seen high up on a barn roof, only its pure shape identifies the piece as a rooster—its painted and cut-out details would be barely visible as its broad sides catch the force of the wind.

Another favorite weathervane of ours depicts a mythical animal (fig. 64), and although it is not as gracefully shaped as the rooster, it too is dependent upon the nature of its outline for identification. Here, each detail does count: the particular way the tail is attached to the body, the prominence of the haunches of the rear legs, the raised ruff on the neck, and the shape and size of the snout. We must assimilate all of these details to form an idea of what kind of beast this might be. Only when it is hoisted up against the background of the sky is its uniqueness in the animal kingdom fully appreciated.

On a much smaller scale, the outline of a prancing horse is placed so expertly on the blade of this tobacco cutter that its silhouette transforms a mundane, useful tool into a visually stimulating one (fig. 65). In this case, its maker also had a practical reason for introducing the horse shape. The four

66

legs helped spread the molten metal throughout the form and gave additional strength to the casting. As with the cock weathervane, this shape is both ornamental and functional.

The design of cast-iron pieces often brings out exceptional artistic abilities in the maker, particularly when the challenge is to create a dynamic three-dimensional object out of identical flat castings. A roof finial we found in western Maryland successfully accomplishes such a feat (fig. 66). Its design is so spirited and joyful that we can share the maker's pride and pleasure in turning four flat pieces of cast iron into a complex and intricate work. When these separate parts are joined together the work springs to life; its shooting arms, circles, and exploding star symbolize the movement of air itself.

The essence of an object, of course, is not solely conveyed by its outline. Some artists use volume to define their subject, as did the creator of the mannequin head intended to display the chic millinery of the 1920s (fig. 67). Its visual impact comes from the fact that we first see it as an object of spherical perfection. The sleekly stylish haircut, arched eyebrows, lipstick-lined mouth, and darkly outlined orange button eyes float on the surface of the sphere but give it the knowing air of a modish flapper.

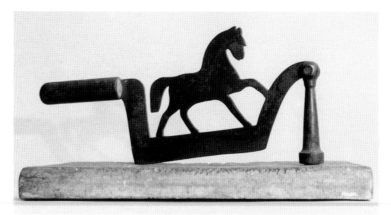

Other artists are able to see a sculptural shape lurking within the confines of a natural object. A sculptor active in northern Vermont, Frank W. Moran, took delight in finding roots or

Fig. 65
Prancing Horse
Maker unknown
ca. 1880
Cast iron on wooden base
7 x 13 x 9 1/4

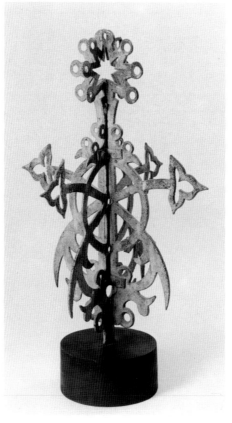

Fig. 66
A Crowning Glory
Maker unknown
ca. 1880
Painted cast iron
24 1/2 x 16 x 16
(photo by Tony Walsh)

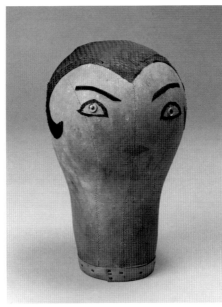

Fig. 67
Flapper
Maker unknown
1920s
Leather, applied fabric,
glass eyes
10 1/2 x 6 3/4 x 6 3/4

three-dimensional form of his subjects was the Saco, Maine, woodcarver by the name of Bernier (fig. 69). We were captivated when we first discovered a large group of carved birds, which were his most frequent subjects. We were impressed by the strong and imaginative coloring of these birds, but we soon came to appreciate that his acute understanding of anatomy was what made his works so striking. He could convincingly create a peacock with swelling breast, a kingfisher with its catch, a shy baby bird, a berry-snitching bird, or a crouching chipmunk. The simple device of using wire legs to perch the birds on

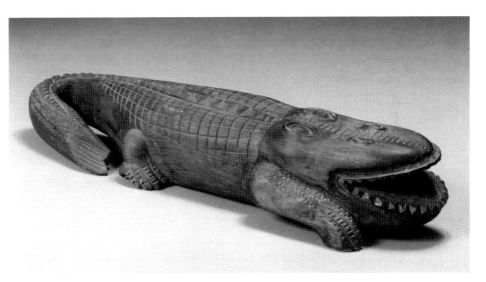

Fig. 68
Alligator
Frank Moran (1877–1967),
East Fairfield, Vermont
Signed "F W MORAN"
1960s
Carved tree root
3 x 5 x 19

logs which with little alteration he could turn into specific animals. In one object that we found he has worked a suggestively shaped tree root to reveal the image of an alligator (fig. 68).

Another sculptor keenly attuned to the

colorfully patterned branches gives them the potential of motion, as if they were about to take off from, or alight on, their perches. Bernier gives the same sense of motion to the chipmunk by having it crouch on its base in a manner that reminds us of a seal in the

circus. By emphasizing a pose difficult to sustain, he makes its body vibrate with anticipated movement.

The artist of the papier-mâché horse (fig. 70), like the carver of the birds, is primarily interested in the solid, tangible mass of the subject. This artist, however, emphasizes the hollows and protuberances of the surface which reflect the underlying anatomical structure of the horse. The stance of the legs, the twist of the neck, and the arch of the back all communicate to us the ideal form of

comes to symbolize all that we find beautiful in the spirited ideal of that breed.

The sculptor of the standing cow (fig. 71) reveals to the viewer what remains hidden in the sculpture of the horse. The barrel-like body of the cow dominates this representation and consists of a single piece of wood shaped to define its mass and volume. All the other appendages—the legs, head, and tail—are conspicuously attached: the legs by crude nails, the head by a peg, and the twine tail by

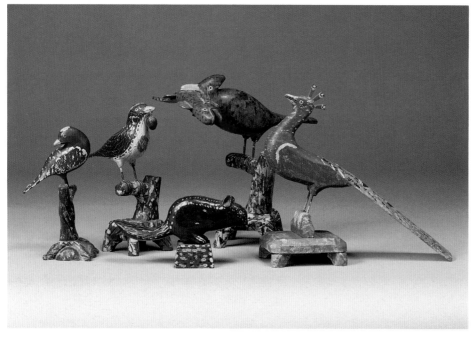

Fig. 69
Animated Animals
Bernier, Saco-Biddeford,
Maine
ca. 1900
Carved and painted wood,
wire legs
4 to 10 high

the horse, which is made more universal than particular because the white plaster surface is left unadorned except for the striking mane of real horsehair. Thus this specific horse

glue. Despite these crudities of technique, the entire piece radiates the visual facts of a real cow—a heavy cylindrical body and large head held up by bony supports. The cow is

because the artist has chosen to emphasize the articulation of the different parts of the animal. No matter how crudely the legs may be attached to its body, they convince us that this cow can and will move, probably just as slowly and aimlessly as real ones do.

As we have seen in different works, capturing the essence of a subject can be achieved in a number of ways, from simple outline to solid form to articulated structure. One of the works in our collection represents another approach which comes closer to a work of pure sculpture (fig. 72). This artist is interested in depicting actual movement. To convey this impression,

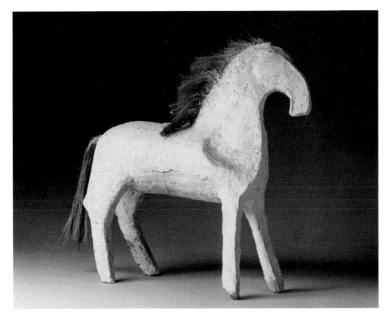

Fig. 70
A White Steed
Maker unknown
ca. 1915
Papier-mâché, horsehair
17 3/4 x 5 x 14 1/2

different from the animals depicted earlier, such as the birds or the horse,

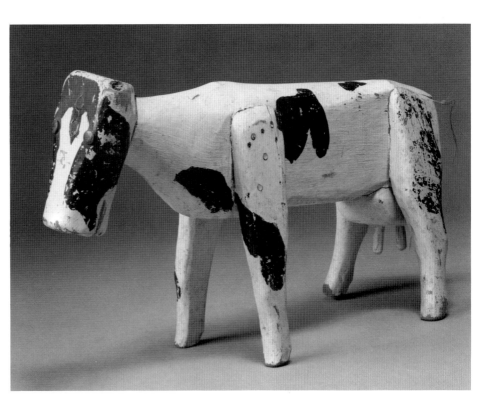

Fig. 71
Only the Essentials
Maker unknown
ca. 1900
Carved and painted wood,
twine tail
10 1/4 x 7 x 18 1/2

Fig. 72
Horse and Rider
M. Prudhomme, farmer in Vermont's Northeast Kingdom
1940s
Papier-mâché, fabric, asphalt shingle
11 x 6 1/2 x 11 3/4

he used papier-mâché, a soft, pliable material, to model the legs and body of the horse in positions reflecting the commands of the rider. Other details, such as the fabric used for the uniform and the harness, add to the realism of this small object. This is more than a simple piece of sculpture because it captures the maker's intimate, and probably daily, awareness of how horse and rider interact.

One final piece both completes and expands the idea of capturing the essence of an object (fig. 73). We purchased this work from its maker, whose home and yard were decorated with many similar, fancifully conceived objects. Someone could easily dismiss this curiosity as just a birdhouse on a stand, but such a comment overlooks the wonderful relationships the artist has established between its different parts. For the principal truth about this birdhouse lies not in its being but in its becoming. Here, as in the body of the cow, it is the articulation of the parts that is the prime focus of the artist as well as the viewer. This artist has schemed to make the birdhouse become the triumphal note of a series of actions.

He does so, first of all, by selecting a modest cross-legged stool to lift the object from the ground, deliberately

Fig. 73
Home for
Brancusi's Bird
Peter Brouck (d. 1993),
Roseboom, New York
1960s
Carved and painted wood
54 x 9 3/8 x 10 1/2

prevails. It is simply a post intended to support a scallop-edged platform that serves as a yard around the birdhouse. Despite this obvious fact, there nevertheless remains in our mind the idea that this is more than just a home for an ordinary bird. Its image suggests that it might be the home of the Firebird beloved by Stravinsky or even a bird like the ones Brancusi himself invented.

choosing a crude device of the simplest form. From this unassuming base, he then introduces a swelling crescendo of upward movement. The three hasty cuttings of a log cannot help but bring to mind a favored motif of the twentieth-century sculptor Brancusi, one he uses to construct his famous sculpture entitled *Continuous Column*. The thick layer of crass green and white paint that covers the piece, however, rapidly puts aside any direct association with Brancusi's work. The home-workshop aura of this piece

A Special Meaning

Objects that have no immediately apparent reason for having been made, ones whose ultimate purposes are obscure, have long had a particular

Fig. 74

A Masked Head

Maker unknown

Early 20th century

Painted wood

8 3/8 x 3 1/2 x 3 1/4

fascination for us. Such mysterious pieces seem to offer clear evidence that their makers were especially intent upon conveying an inner vision or a heartfelt emotion. The message of some of these impenetrable works will never be clear, but their aura of mystery is so pervasive that even though some may be crudely executed we think they lay special claim to consideration as works of art.

The strangely contorted bust of a man (fig. 74) whose masklike face rivets our attention is a work that has an inescapable impact. Its maker has perched the head on the body at a slight angle and with scant hint of a neck. Without this flexible part of the figure's anatomy, our eyes focus on the piece almost as if it were made up of two abstract shapes balanced one on the other. Viewing the sculpture this way, we keenly sense the dominance of the darker upper part which is further empowered by the white inlay of the eyes. Reduced to a play of simple forms but endowed with human features that transfix us, this piece conveys a strong emotion to all who see it.

Fig. 75

Imprisoned Man

Maker unknown

Date unknown

Wood

7 1/2 x 6 1/4 x 4 3/4

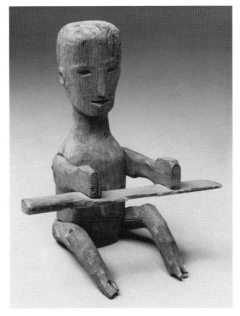

Another small carving of an enigmatic figure (fig. 75) may be an unfinished or discarded part of a whirligig. Its surface is probably due more to weathering than intent, but its roughness makes it seem as if the carver deliberately wanted it this way so the very minimal facial features would appear more mysterious. Another aspect of this

figure that puzzles us is that even
though the arms and legs are movable,
the arms cannot be freely articulated,
as they are attached firmly to a
horizontal strip of board which appears
to be held out to us. Is this figure a
prisoner? A beggar? We see objects
like these filtered through our
knowledge of other similar works and,
perhaps because of that, invest them
with greater significance than their
makers might have intended. This is
probably why, given a lack of specific

knowledge about this piece, it takes on
for us the appearance of a mysterious
artifact.

We have never been able to puzzle out
what the maker of this boxed assembly
of various objects (fig. 76) intended to
convey by bringing them together. In
addition to simple curiosity, we were
visually attracted to this piece because
of the dense layers of different textures
the maker has built up out of this odd
assortment. On the bottom is a naval

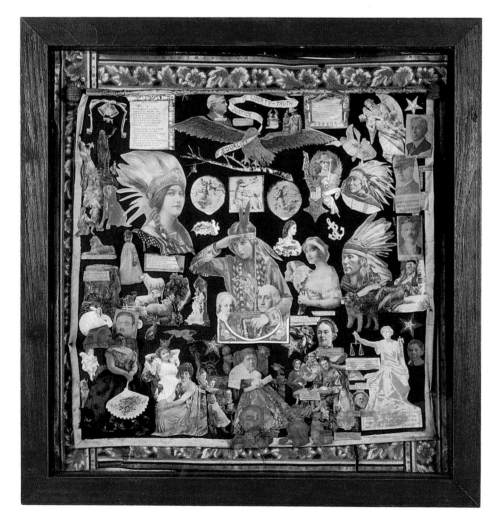

Fig. 76
"Old Indian Relic"
Maker unknown
ca. 1910
Illustrations and articles from
newspapers, photographs,
textiles, wallpaper borders
34 x 34 3/4 x 4

flag which is surrounded by a colorful wallpaper border and then haphazardly covered over by newspaper clippings, photographs, handwritten memos, and inscriptions. The comments by the maker do not, however, enable us to crack the riddle. How, for example, can we evaluate the significance of the comment written next to a photograph of James B. Aswell asserting that he was "one of the greatest men in America"? Even learning that J. B. Aswell was an educator and a member of Congress

(1913–31) from Louisiana has not helped us to answer this question.

Other figures included among the clippings are equally elusive. We have not yet figured out why the maker included four illustrations of Native Americans in this crowd of images, thus causing it to be labeled by the antique dealer as an "Old Indian Relic." What is the meaning of the "maiden" in the feathered headdress who, looking out from beneath her upraised hand, scans the horizon while at the same time cradling the heads of Martha and George Washington in her other arm? And we would like to know more about the ponderous female figures who, seated at the bottom of the work, exude an ominous air of judgment, despite the fact that two of them are dressed in billowy skirts made out of actual gauze and tinsel.

The creator of *A Family Heritage* (fig. 77) states its message directly, displaying the family lineage in a literal image of a tree. Not content with just drawing a tree, the maker used wire wrapped with green silk to form the tree's trunk and branches. To personalize each entry the leaves were fashioned from the hair of different family members, each of whose names and life dates were inscribed nearby. Executed in this way it gains an immediate and emotional meaning as a record of the Sheldon family from 1785 to 1845. It is an evocative demonstration of the family pride felt

Fig. 77

A Family Heritage

Maker unknown

ca. 1850

Silk-wrapped wire branches with leaves made of human hair

17 1/2 x 14

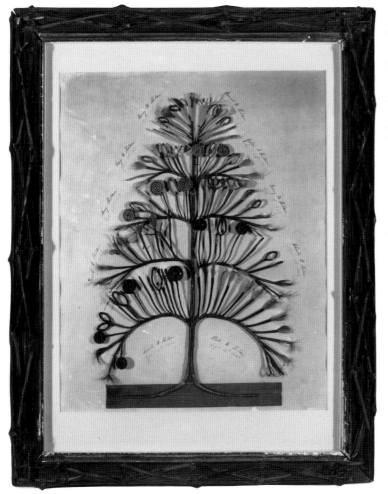

by the isolated farmers in the North Country of upper New York State.

Pride in the achievement of a family member is also expressed in a humbler memorial (fig. 78) made of sketches grouped around a photoengraved portrait identified in a separate autograph as A. F. Davenport. Skill in penmanship was one of his accomplishments, as is evident from the calling card showing the Lord's Prayer written in the space of a penny—a standard measure of calligraphic talent. The other, more amateurish drawings reveal more about him. We believe they tell us of his visits to what were then faraway places and different societies. On his return he probably told his family about his run-in with the giant mosquitoes in Minnesota swamps and also about seeing a "Colored Individual." At some point, perhaps after his death, a family member put together these simple pieces as a memorial, thereby evoking not only the man but the cultural environment at the time he lived.

Sometimes the emotional impact of a piece does not emerge immediately. At first glance, this work (fig. 79) appeared to us to be a part of the fad that swept the nation in the early twentieth century of pasting cigar bands on the back of glass surfaces to create decorative bowls and ashtrays. We admired this piece because its maker had arranged the cigar bands in

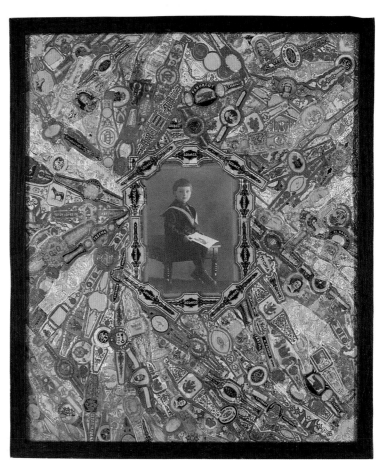

Fig. 78
Souvenirs of a Calligrapher
A. F. Davenport
ca. 1880
Pencil on paper
16 x 13

Fig. 79
In Loving Memory
Maker unknown
ca. 1900
Photograph and collage of printed cigar bands pasted on glass
12 3/4 x 10 3/4

a much freer and more colorful pattern than others we had seen. Only after owning it for a while did we notice how

while a parent was fitting the artificial flowers, buttons, and foil into the other bottles. Of course the mystery remains

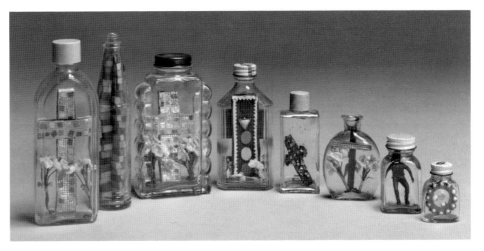

Fig. 80

Washed upon the Shore

Maker unknown

1970s

Glass bottles filled with

various materials

2 1/8 to 6 3/4 high

abruptly the swirling pattern comes to a stop at a chain of identical black cigar bands bearing the brand name of "SOLACE." This single, poignant word, enframing the photograph of this nine-year-old boy, transformed an ornamental piece into a touching memorial.

This group of little bottles (fig. 80) is readily associated with the tantalizing notion of mysterious messages found in bottles washed ashore. Since five of these vials contain jewellike images of the Holy Cross, the likelihood of their having a special meaning is reinforced. On the other hand, it seems quite unlikely that since one of the bottles contains a plastic spaceman we are in the presence of a message from another world! A more reasonable inference is that it was made by a child

as to how any of the objects were actually put into their containers.

A deeper and more tantalizing conundrum is posed by this sculpted piece of unknown origin (fig. 81). Because we are unable to anchor this object in time and place, it possesses an even greater enigmatic quality. One story suggests it was salvaged from a demolished theatre in Brooklyn, New York, but this idea is unlikely, because the row of heads is carved from a single block of stone and such decorative details in nineteenth-century American architecture were rarely so ambitious. Terra-cotta or cast-stone sculpture would have been far cheaper to employ for this purpose. Regardless of why this piece was made, what gives it such a compelling force is the intensity and specificity of expression given to each

Fig. 81
A Single Stone with
Five Riddles
Maker unknown
Date unknown
Stone
10 1/2 x 36 1/2 x 8

of the heads, like the individualized carvings found on medieval cathedrals. Another peculiarity of this piece is that each of the heads is fashioned into a distinctive type. Their juxtaposition makes it seem as if they were to be an illustration of the different human races, but this suggestion is unlikely as they have similar head coverings. The mystery of the origin and purpose of this sculpture does not detract from, but rather adds to, its impact as a work of art.

Another sculptural mystery is this pair of simply crafted heads (fig. 82). Were they intended to be theatrical stage props? Or did their maker see them as independent decorative works? The question is worth posing, if only because their power is so immediate and their insistent expressions so meaningful. We do not know what they signify, just as we can never be sure

about the meaning of the smile on the face of the Mona Lisa.

An altogether different type of object (fig. 83) turned up in a box of miscellaneous crockery offered at a

Fig. 82
Smiling Heads
Maker unknown
1930s
Wood
14 3/4 x 6 3/4 x 7;
13 1/2 x 6 1/2 x 7

local auction near our country home in northern New York State. When we first glimpsed these two curiosities made from the vertebrae of either an ox or a horse, we had no idea why they were painted to resemble religious personages. We nevertheless were convinced they were more than simple decorative or functional articles, even though the auctioneer offered them as candlesticks! These miniature figures possessed a palpable spiritual presence not unlike that of the revered totems of distant cultures or tribal religious cults.

breakaway Quaker sect. She had led her group into the wilderness of New York State in 1792 to found the community of New Jerusalem, where her followers continued to live until 1874. This fortuitous identification helped suggest a reason for the female figure being represented as the larger of the two and for her wings being painted a distinctive color. Although this new knowledge still did not reveal why these objects were made, it did sustain our conviction that they had a distinct message.

Fig. 83
Significant Bones
*Maker unknown
(objects found in northern
New York State)
Date unknown
Painted ox or
horse vertebrae
Female figure, 5 1/2 high;
male figure, 4 1/2 high*

Imagine our astonishment years later when we recognized from an illustration in a newspaper article that the facial features of the female bone figure resembled those of Jemima Wilkinson, a leader of an eighteenth-century

Some paintings possess an inscrutability about them that easily engages our attention and holds it fast even though their maker has not deliberately set out to do so—unlike paintings created by such Surrealists

as Magritte, de Chirico, or Dali. The painting of five figures gathered around a garden table (fig. 84) has such an attraction for us. Although we as viewers seem to be positioned close to this group, the artist also excludes us by having three of the participants turn their backs to us. We remain, however, within listening distance, as if in a crowded restaurant. The artist gives us not the slightest hint of what is animating the exchange between the standing man and the

meaning still eludes us. We hope a Proustian friend may pass by to enlighten us.

Architectural objects rarely prove mysterious. While sometimes exotic and fanciful, they usually have a readily discernible function as a birdhouse, dollhouse, or model building. One of the objects we found cannot however be so readily categorized (fig. 85). Not intended for use by either dolls or birds, this structure must have been

Fig. 84
View from My Table
Artist unknown
ca. 1920
Oil on canvas
28 x 38

stylish woman in white. Brought to the point of understanding what incites all the gestures and expressions of this group, we are frustrated as the figures seem to freeze into a tableau whose

built solely to express some inner vision. And even though the vocabulary of arches, towers, and spires speaks of elegant and graceful works, the maker seems stubbornly to

avoid achieving such an effect. The manner of execution is, of course, what keeps us from seeing this work as strictly fanciful. The harshly painted masonry, crude asphalt shingle roof, and awkward wooden turning of the spires give this building an authenticity that makes it real rather than magical. The purpose of making such an ambitious work remains unclear, but we believe this artist has triumphed in turning a vision into a tangible form.

Fig. 85

Made to Order

Maker unknown, said to be
from south central
Pennsylvania
ca. 1900
Painted wood, asphalt
shingle roof
41 3/4 x 31 1/2 x 16 3/4

Love of Architecture

The fervent interest in architecture that Isabel and I share underlies our passion for objects whose makers express themselves through architectural imagery.

Sometimes these works appeal to us simply because the artist has interpreted an actual building in such a

that she did not blindly copy a photograph. Instead, she selected, reassembled, and altered in a personal manner the information provided by the reproduction. She has compressed the distance that actually exists between the temple of Nike on the brow of the Acropolis and the Parthenon further back, with the result

Fig. 86

A Greek Fairy Tale

Signed lower right "Estelle Vassos," Chicago, Illinois

ca. 1985

Oil on canvas

30 x 42

way that it takes on a new reality. This play between different perceptions of reality is what drew us to the painting of the Acropolis (fig. 86). The artist herself told us she had copied a large black-and-white photograph to make the painting. Despite the artist's belief that her effort was mere imitation, it is clear to anyone familiar with the site

that all of the buildings appear to be lined up in a row. Rather than crowning the hill and monumentalizing the approach, the whole architectural complex becomes, in our artist's hands, a scenic backdrop despite her laborious descriptions of the masonry blocks of the slanting ramparts. Both her patient attempt to convey the

Fig. 87
The Pools at Biltmore
Signed and dated lower left
"Marino Auriti, 9-1-1961"
Acrylic on canvas
34 x 52

solidity of the architecture and her free reorganization of the buildings makes the Greek monuments more the product of her own invention than the paragons of classical architecture that we admire.

When released from detailing architectural forms, her brush appears to free itself when filling the sky with clouds and foresting the landscape. She obviously delights in painting trees—so much so that she blankets the rocky slopes with stylized Christmas trees, which combined with the clouds seem to turn her painting into a decorative wallpaper mural. In her hands the familiar Acropolis becomes a new and different place. The architectural splendor of this sacred site has been replaced by a

joyous, toylike setting akin to an illustration of a mountaintop castle in a child's fairy tale.

We enjoy this painting of Biltmore, the Vanderbilt mansion at Asheville, North Carolina (fig. 87), for similar reasons. Here, too, the artist's personal vision enhances and alters our visual perception of the building. Although this work is dated 1961, its palette derives from the airbrushed colors of a 1930s postcard, as does the choice of a foreshortened view across the reflecting pools—an angle favored by architectural photographers of that time. What makes this painting so fascinating, however, is the artist's interpretation of his source. He chose to work on a majestic scale that allowed him to depict fully the towers

and arches of the mansion twice, as mirror images in the reflecting pools and as representations of the actual building. By doing so, he creates an architectural fantasy that enlarges the truth of the actual building and thus comes closer to what the architect's presentation drawing must have promised.

reflecting pools, the plane of the painted canvas dominates. The three-dimensional building is flattened out into a series of geometrical shapes stretched across the surface. The dichotomy between the postcard reality of the finished painting and the artist's intention is what gives this piece its particular punch. A final irony

Fig. 88

Home of E. Mertz

Signed lower left "J. Hall,"
said to be from Lima, Ohio
1880s
Oil on canvas, floral
painted frame
21 x 30

The artist of this painting is so totally preoccupied with the challenge of laying down the paint to represent the reflecting pools that these areas of water become powerful fields of color on the surface of the painting. Any sense of space and illusion he wished to achieve is lost. Regardless of the great plunging diagonals of the

of this postcard-inspired piece is that it is as far removed from a realistic painting of Biltmore as the house itself is removed from the original French Renaissance chateau of Blois which inspired the architect.

Other painters of architectural subjects have worked directly from buildings at

hand, as the modest portrait of the house of E. Mertz demonstrates (fig. 88). The painter of this scene posed the small frame house against a broad expanse of sky and land, but separated it from the undefined landscape by a sparkling picket fence that never quite ends. The mottled sky and the empty foreground give a sense of isolation to the house, true to its midwestern location. An orderly community is suggested by the fence and the name of the owner painted on the front door.

Although the painting of the Mertz home conveys a sense of the owner's pride, and probably was why its portrait was made, it lacks details concerning the construction of the house. We would be hard-pressed to make an accurate three-dimensional model. By contrast, the artist of the drawing we call *Victorian Delight* (fig. 89) has tried to provide us with all the details necessary to understand this Queen Anne–style residence as a constructed object. To render a realistic view of this Victorian house—with its bay windows, octagonal towers, projecting porches, and many-angled roofs—would require sacrificing some descriptive details to show the building in the natural world of light and shadow. But this artist cannot do so, instead doggedly setting down each shift of wall and change of depth in the building and insisting upon including all the myriad ornamental details. In taking this path, however, this artist accidentally comes

closer to the spirit of its architecture than someone more skillful might have done. This penchant for detail is equal to the passion of the Victorian architects who delighted in piling up such an illogical accumulation of architectural elements. This building was never intended to be captured in a single, static drawing, but experienced over time.

With architectural paintings, one cannot always be sure whether the artist's vision was inspired by an actual building or simply emerged from the imagination. *The Lakeside Villa* (fig. 90) at first appears to be the work of an artist obsessed with the roadways passing by and encircling the house. On reflection, however, we realize that the sinuous curves of the roads were seen more as decorative

Fig. 89

Victorian Delight

Inscribed on reverse
"Drawn by W. Meas"
ca. 1930
Crayon, pencil, ink
on paper
15 x 19

Fig. 90

The Lakeside Villa

Maker unknown, said to be
from North Carolina
ca. 1950
Oil on composition board
11 x 17

Fig. 91

Mouse Castle

Maker unknown
ca. 1870
Painted laminated wood,
gilt wire, painted and
carved wooden decoration
26 x 29 1/2 x 20
(photo by Tony Walsh)

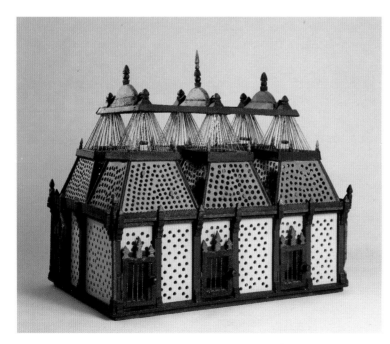

embellishments for the painting than as actual driveways. The artist's delight in the ornamental also affects the depiction of the house itself, and more attention is devoted to its decorative trim than to its structure. The illumination from within creates the impression of interior space but also makes the villa look more like a dollhouse than an actual residence. This suggestion of the make-believe alters our understanding of the whole scene; the passing boat becomes a toy sailboat and the driveways welcome only miniature cars. Accordingly, this painting becomes less a portrait of a specific place and more a description of an imaginary world of decorative shapes and colors contained in its own expressively painted frame.

Fantasy architecture finds an outlet in more than just drawings or paintings. Three-dimensional fantasy buildings present the greatest challenge to a maker's creativity and skill. Some lucky

child must have had a relative help make this exotic home for a family of white mice (fig. 91). The gilded wire spires, gray roofs, and cream-colored walls of this castle may have been inspired by the gold domes, slate roofs, and sandstone walls of governmental buildings of the time. There is nothing bureaucratic, however, about this construction. The exuberant red, green, and gold rooftop ornament is a completely original invention and transports the building into a world of fantasy. Imagine the endless animation in this royal residence when the white mice entered their six compartments through the circus-cage doorways and scampered up to their perches to swing by their tails from the trapezes hanging in the gilded turrets.

Other constructions for pets—such as doghouses or rabbit hutches—only rarely seem to achieve an expressive quality. Birdhouses, however, often inspire fantastic creations. Although most are cute or corny, rather than expressive of architectural imagination, an exception is one of our favorite pieces, which we titled *A Presidential Residence* (fig. 92). This birdhouse is a straightforward wooden box with sharply cut-out entry "windows." It gains class and architectural standing, however, by the addition of a two-story, semicircular columned portico. This combination of a severe, unadorned mass and a graceful columnar motif was exactly the essence of the very best early Federal architecture, for which the White House provided a national model.

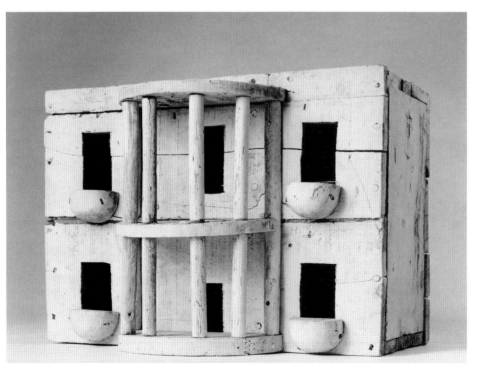

Fig. 92

A Presidential
Residence

Maker unknown, said to be
from Tennessee
ca. 1910
Painted wood
12 1/2 x 18 1/4 x 12 1/2
(photo by Tony Walsh)

Fig. 93
An Adobe Haven
Maker unknown
1920s
Painted wood
11 3/4 x 14 3/4 x 9 1/2

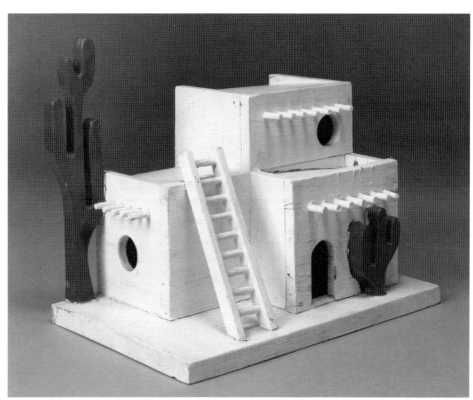

Another birdhouse (fig. 93) captured our imagination because it seemed to set the standard for a typical product of a home workshop. Perhaps following a pattern published in *Popular Mechanics* or *Boys' Life*, this maker carefully created a two-tiered house and provided for the birds' needs by including all the architectural details common to a Pueblo Indian dwelling. With ladder, projecting beams, and cacti the maker has created an environment appropriate for winter migrants although, in fact, this house more likely was placed in the yard of a northern home.

Our love for architectural objects was more than fulfilled when we discovered this homemade treasure (fig. 94). As no coins were left in this building-fund bank when we acquired it, we trust the "YMBC" congregation reached their goal and were able to build a handsome church. We can only hope, however, that the actual church did not mimic the bank, whose chunky corner towers and oversized rear chimney are far from the ideal of a graceful building. We want to believe, though, that they were able to install stained-glass windows like the ones seen here, for their colors are wonderfully vibrant—like paintings by

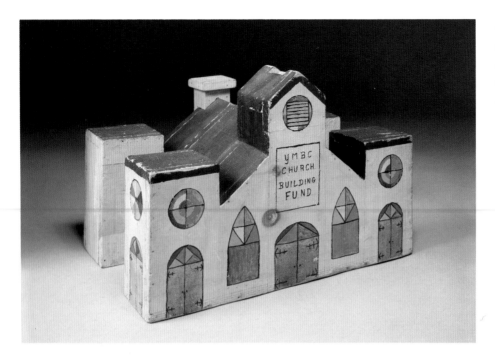

Fig. 94
Raise the Roof Beams
Maker unknown
ca. 1905
Painted wood
12 x 18 1/2 x 12

Delaunay—and certainly reflect the loftiness of the congregation's dreams.

We never thought we would be fortunate enough to find even a single painted window screen, much less five from the same house (fig. 95). Isabel had spent her childhood summers in Baltimore, Maryland, where there was at that time a rich concentration of these summer decorations. In the mid 1940s, she had taken me to see them, and I will never forget the sight: long streets flanked by white stoops leading up to identical red brick row houses glistening with painted window screens.

These screens are part of a long and intriguing tradition of using ornamental paintings to shield the view into a house while still allowing those inside to see

out. (Today this tradition lives on in the one-way scenic views applied to rear windows of vans.) Manufacturers of wire window screens offered "landscape screens" in their sales catalogues as early as the 1870s. However, there also existed bands of itinerant artists who worked up and down the Eastern seaboard turning rows of tightly packed houses, built flush to the sidewalk, into lushly landscaped illusionary neighborhoods. These painters seem not to have returned after the Second World War— their place, but not their artistry, being taken by salesmen selling flamingo-decorated aluminum screen doors.

Baltimore, however, retained its tradition because of the presence of a number of resident artists who painted

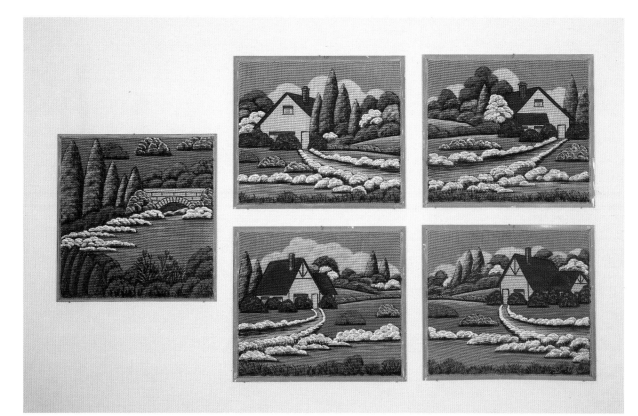

Fig. 95
An Idyllic Suburb
in the City
Attributed to
William A. Oktavec,
Baltimore, Maryland
ca. 1940
Oil paint on aluminum
window screens
29 x 28 (one);
26 x 30 (four)

screens. One artist, William A. Oktavec, particularly favored scenes either showing arched bridges among flowering trees or depicting cottages set at the end of curving paths bordered by bushes and flowers. Our screens are probably from his hand.

(Only when writing this description of the screens did I find the wonderful book America's Forgotten Folk Artists *by Fred and Mary Fried, published in 1978, which describes the history of painted screens and, particularly, of the activity in Baltimore. Thanks to them we have been able to suggest the identity of the screens' artist.)*

Power of the Word

Phrases, words, or just letters are often parts of works of art, and we have always been attracted to examples which celebrate the delight artists took in combining written and purely visual forms.

We detected a very elementary example of such a combination in this desk from a rural Vermont school (fig. 96). Sharp penknives and tolerant teachers allowed a few pupils, presumably in the back of the schoolroom, to carve a graffiti-like work of art over the course of many years. Within the history of art, this desk finds parallels in Paleolithic drawings as well as in the spray-painted graffiti on subway cars. Whether on the wall of a cave or on this desk top, some of the simple images are the same: stick figures of a person, geometric symbols, an outlined hand proclaiming the existence of a human maker. A key difference between the two is, of course, the score of initials, letters, and numerals on the desk top which indicate that this object belongs to a literate society. Its teachers are hired to pass on this knowledge to another generation, no matter how great the obstacle.

Fig. 96
"Pen" Manship Class
Carvers unknown
Dates between 1890 and
1910 on desk top
Wood, cast-iron legs
28 1/4 x 46 x 16 3/4

Fig. 97

This Tool Belongs To

Daniel Alben

ca. 1875

Ink on wood

4 x 25 x 5

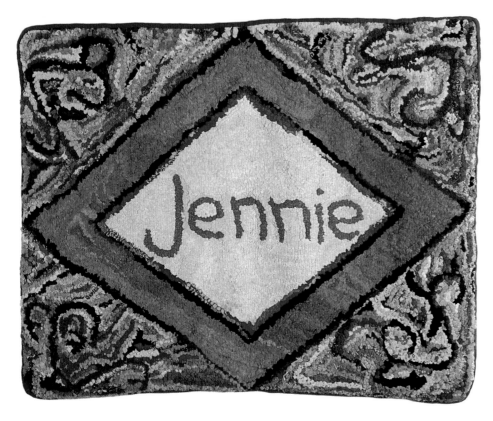

Fig. 98

Jennie's Rug

Maker unknown

ca. 1880

Cotton hooked on burlap

32 x 41

Our love of letters encompasses even simple objects like this inscribed harnessmaker's tool with the owner's name diligently lettered on the side (fig. 97). Indeed, each character is so carefully drawn and arranged that it suggests to us he was unfamiliar with the art of writing and simply copied each letter of his name. No doubt he brought a similar determination and pride to the work he fashioned with this tool, his leather straps and

thongs probably being prized as articles of superior artisanry.

Given our penchant for letters and words, it was no surprise our eyes tingled when we first spotted this rug bearing the name "Jennie" (fig. 98). It came at us like a blinking neon sign. We do not know whether the rug was made by Jennie or presented to her. But the stark contrast between the

choice of thick, angular letters, the placement of the traffic light red–rectangle to signal the pause required for the rhythm of the verse, were probably all instinctive acts on the part of the maker to reinforce the homey motto. This message is put into an even more meaningful context when we realize that the shape of the rug shows it was intended to be placed before a

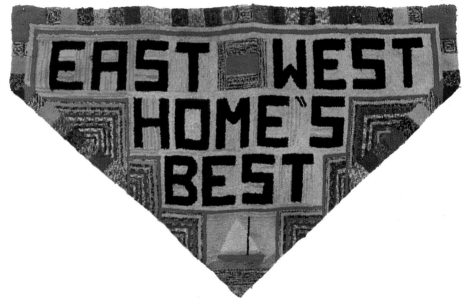

Fig. 99
Keep the Home Fires Burning
Maker unknown
ca. 1920
Wool and cotton fabric hooked on burlap
34 x 54

richly colored, decorative corners and the pure white center with its dazzling letters gives this rug a distinct personality that we associate with Jennie herself.

For the same reason we could not resist this large, finely hooked rug which proclaims its message so commandingly (fig. 99). The maker's

hearth. The diagonal sides were made to accommodate twin armchairs before the fire. Not until we had lived with it for a while, however, did we come to see how the seemingly out-of-place little sailboat painted in lighter hues allows a perfect escapist afterthought.

We couldn't believe our luck when, at a flea market, we came across a window shade which we immediately recognized as being related to similar works by the Missouri folk artist Jesse Howard (fig. 100). He was an extraordinary man who painted the walls, doors, and shutters of houses with texts from the Holy Bible. So densely did he crowd these inscriptions together that their specific messages became almost indecipherable. An environment filled with these insistent painted messages could seem almost deafening. Experiencing such a surrounding was like seeing the calligraphic letters of the Koran or finding oneself completely enveloped by the walls of the ancient Egyptian tomb chamber of Unas, which are totally filled by lines of hieroglyphic texts.

Although the window shade is only a fragment of one of Jesse Howard's larger group of signs, it too evokes a mystic and powerful impression. The density of its rows of ruled lettering covering the entire surface and the sparse but strident use of reds for certain phrases—making them scream out from the rest—provide a glimpse of the totality of his creations. As a single, tangible object it gives us an intimate glimpse of this artist, who interrupts his quoting the biblical text to speculate: "I wonder if President Jimmy Carter ever read this out of his Holy Bible."

Professional calligraphers created documents for both families—such as the elaborate Pennsylvania birth and marriage frakturs—and businesses—such as fancily lettered commercial records and advertisements. We

Fig. 100

A Window Shade Exegesis

Jesse Howard (1885–1983)

ca. 1978

Ink on canvas window shade

45 x 28

found one artifact of this latter category so peculiar in its choice of imagery and lettering that we wanted to know more about the artist and why this work was considered appropriate for its subject (fig. 101). Why should a depiction of Saint George slaying the dragon have been chosen to represent the school of shorthand at this Troy, New York, business college? Perhaps, as we believe, it was simply an excuse for

ornament also seems strange. What possible connection can there be between nesting birds and secretarial skill? Or, why the use of cattail embellishments for the typography of the college's name? Only the lettering for the school's title seems to be appropriate. Its Gothic forms and curlicues can be imagined to represent the shorthand markings made by the students on their stenographic pads.

Fig. 101
Patron Saint of Stenographers
Maker unknown
ca. 1880
Photolithograph
13 x 18

the calligrapher to show off skill with the pen, rendering the writhing hide of the dragon so convincingly that the softer forms of Saint George and his mount seem to be in peril. The calligrapher's choice of border

Calligraphers took great pride in using their talents to give patriotic documents a presence which aroused fervor and awe. To illuminate these lofty ideals they called upon all the powers of their

art. Given our love of both lettering and patriotic objects, we derived special pleasure from works that combined these twin elements.

Two printed examples show how the calligrapher's art provided particularly spirited works to honor President Washington. One is a memorial piece dedicated to the "Illustrious Champion of Liberty" by the engraver John I. Donlevy (fig. 102). He endows almost every word of his inscription with a different lettering style and with many flourishes of the pen. The incredible virtuosity of the piece no doubt accurately expresses the deep

Fig. 102
"Illustrious Champion of Liberty"
Inscribed on bottom "John I. Donlevy . . . Engraver"
1840s
"Intaglio-chromographic and Electrographic"
engraving
17 x 13 3/4

Fig. 103

The Image and the Word

*Inscribed upper center
"Designed and executed . . .
by Gilman R. Russell . . .";
at bottom
"Published by Wm. H. Fisk,
Manchester, N. H.";
"J. H. Bufford's Lith."
Copyrighted 1856
Lithograph
27 x 21*

feelings and respect he and his "fellow citizens" held for the founder of our country.

The second work incorporates a figure of Washington—in a pose made familiar by Gilbert Stuart's portrait—standing within the sacred words of the Declaration of Independence (fig. 103). The title of the document is framed by two quill pens, crossing at the top center to form a perch for the emblematic eagle. Below the eagle a circular

plaque boasts: "The Original of this was / DESIGNED & EXECUTED / entirely with a / PEN / BY / GILMAN R. RUSSELL / TEACHER OF / Practical, Plain & Ornamental / Writing AND Drawing." The significance of the two crossed pens is clear. One represents the patriot writers of the original document; the other, the artist who executed the calligraphic version.

The stern presentation of the Declaration of Independence in the previous piece—almost as if it had been written at the command of the president's sword—is replaced by another calligraphic representation which is imbued with a celebratory air (fig. 104). The wide wingspread of the eagle, the billowing swags of patriotic bunting, and the presiding figure of Liberty seated on a throne all seem reminiscent of a Fourth of July celebration replete with splendid oratory. Despite its small size, this work rings out with stentorian, heartfelt sentiment. The maker has undertaken a dazzling exercise in writing so finely that one wonders whether the artist used a writing pen or a sewing needle. The minuteness of the script, the almost unbelievable regularity of the cursive writing, and the arrangement of the words to form the burst of light above the eagle are feats daunting to even an exceptional master. Through all of these talents, this artist evokes the memory of sunny Fourth of July

days like the one that unfolds in Eugene O'Neill's play *Ah, Wilderness!*

The calligraphy of W. H. Pratt (fig. 105) raises our patriotic sentiments to an even higher emotional level. Again we are amazed at the ability of a master penman to turn a document into a work of art. The incredibly beautiful, uniform, and flowing script

Fig. 104

Celebrating the Fourth

Maker unknown

ca. 1875

Ink on paper

12 3/4 x 9 1/2

underscores the importance and poetry of Lincoln's Emancipation Proclamation. The artist makes it even more affecting by selectively altering the pressure on the pen to cause a ghostlike face of Lincoln to emerge from the written words of the text. No other work, in our estimation, so clearly exhibits the powerful possibilities of the combination of words and visual images.

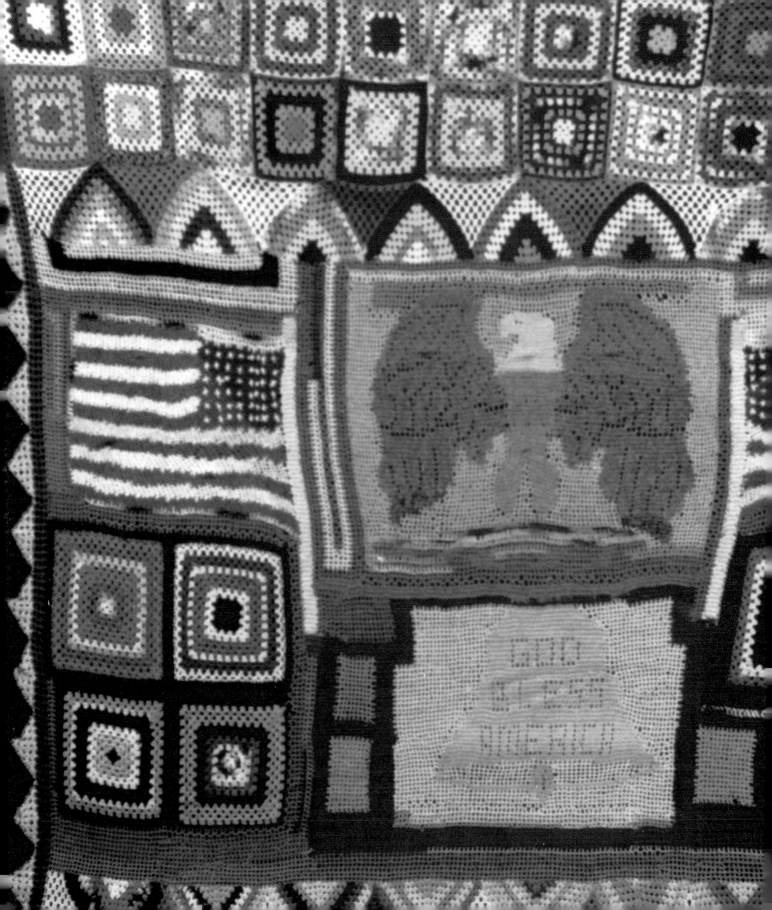

Pride of Country

No passion so drives the artists of our country as does the expression of patriotism. To celebrate the heroes of America's past and to emblazon its national symbols in paintings, prints, or sculpture has been a duty assumed by artists from 1776 onwards. While some "artists" have done so on a mammoth scale, like the Illinois farmer who planted a six-acre field with red, white, and blue petunias in honor of the 1976 Bicentennial, our attention has centered on more modest efforts which display equally original approaches.

Two pieces in our collection show how different artists represented the symbol of America's strength—the eagle—and its accompanying attributes. The work of a nineteenth-century patriot who depicted the eagle in naturalistic detail (fig. 106) becomes more meaningful when we realize it is created almost completely of painted feathers.

Fig. 106
A Feathered Emblem
Maker unknown
ca. 1840s
Painted feathers mounted
on board
16 x 15 3/4

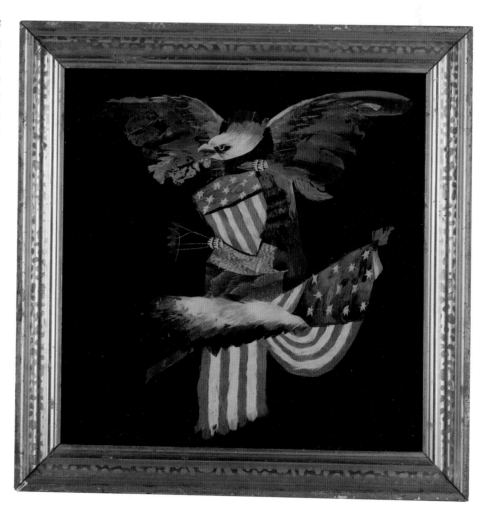

A witty design from the 1930s (fig. 107) reinvents the image of the eagle by combining icons of American life. The feathered headdress of a Native American and the trunk of a Republican elephant give shape to the bird's wings while its head is made by joining the U.S. Capitol and an automobile. The traditional arrows and stars arranged around the eagle are transformed into 1930s skyscrapers and medallions containing initials taken from the "alphabet-soup" agencies of the New Deal. Perched on a hot dog rather than its usual olive branch, this eagle design is very much a symbol of its time.

A very different sentiment is expressed in two unusual pieces (figs. 108, 109) created in honor of two of our country's most illustrious heroes. These memorial figures are believed to represent an early custom of fashioning miniature effigies of famous men at the time of their deaths. They might have served during the period of mourning as shoulder badges, much like the custom still prevalent in many countries of wearing black armbands. The body of the George Washington effigy is made up of several parts cut out of a stiff envelope on which a partial handwritten address including the word "Boston" is still visible. His clothing is pasted and sewn onto the paper armature. Judging from the materials used and the manner of execution, it is most probable that this piece was made at the time of the first president's death in 1799. The Lincoln effigy was probably made at the

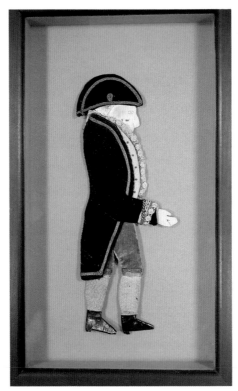

Fig. 107
A New Deal Eagle
Designer unknown
Manufactured by
Schumacher & Co.
1930s
Printed wallpaper
19 1/4 x 20 3/8

Fig. 108
Honoring Our First
President
Maker unknown
ca. 1800
Body cut out of stiff envelope,
velvet coat and hat, lisle
stockings, leather shoes, wool
breeches, lace shirt front and
cuffs, hand and face drawn in
ink and watercolor
10 high

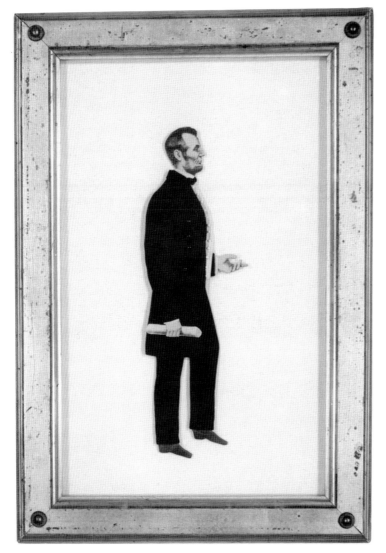

Another piece related to the time of Lincoln is the unusual print (fig. 110) sold in the 1890s to raise funds for the erection of an enormous Civil War memorial entitled the *Easel Monument.* It was to be built, promoters said, in honor of the Union Army's "Boys in Blue." Widows, orphans, and veterans were encouraged to contribute to its construction by purchasing this print. As an added incentive, each print could be made into a personalized monument by recording the veteran's military exploits in elaborate script on the blank panel of the print. (Our print is inscribed with a description of the military record of Alpheus H. Taylor, who presented it to his wife in 1893.) Although shown here as if gracing Fairmount Park in Philadelphia, the memorial, alas, was never built, depriving the City of Brotherly Love of a giant bronze monument with which that city's current architectural doyen—Robert Venturi—certainly would have been sympathetic.

A more tangible expression of patriotic sentiment is embedded in the strident, almost brazen presentation of the nation's symbols in a wildly crocheted afghan (fig. 111). Its maker seems impatient—not even bothering to make sure the crocheted squares are all the same size—as if unable to wait to get the message across. Instead these squares are frantically jammed together to form a hot, crowded mosaic of wild colors at the top and bottom of this bedcover. The maker's

Fig. 109

A Lincoln Memorial

Maker unknown

ca. 1865

Wool suit, silk vest and cuffs, leather shoes, glass buttons, lithographed head and hands

10 high

time of his assassination, but it is a more elegant, almost professional work. His face and hands are cut from a lithographed portrait of the president. The tiny glass beads for buttons are attached to the wool suit with minute stitches, and the leather shoes are carefully crafted.

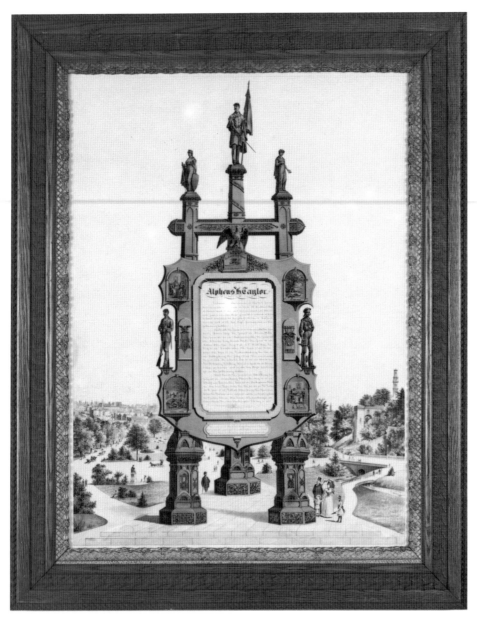

Fig. 110

The Easel Monument

Monument designed by the Monumental Bronze Company, Bridgeport, Connecticut

1893

Published by Dux Publishing Co., Philadelphia, Pennsylvania

Photolithograph

31 1/2 x 23 1/2

pace then seems to slow when working on the central area with its thunderous symbols of the eagle of the United States and the Liberty Bell. Here special stitches are used to make the feathers of the eagle appear as lifelike as possible and to create a metallic surface (a brass, not a bronze one) for the bell which rings out "God Bless America." Everything about this object speaks vividly of World War II America, the artist probably crocheting it while

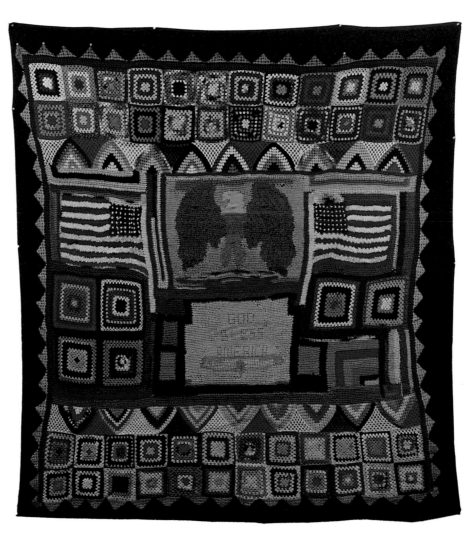

Fig. 111
God Bless America
Maker unknown
1940s
Wool
70 x 70

Fig. 112
"Spirit of '76 Lives On"
Fern Bisignano, Glens Falls,
New York
1976
Oil on canvas
14 1/4 x 19 1/2

listening on the radio to Kate Smith's theme song, "God Bless America."

After that clamorous work, seeing the winter landscape by the Adirondack painter Fern Bisignano (fig. 112) is a relief. So peaceful and soothing is this scene with its muted palette that we almost miss the hidden Bicentennial message that nature and a coy artist have presented.

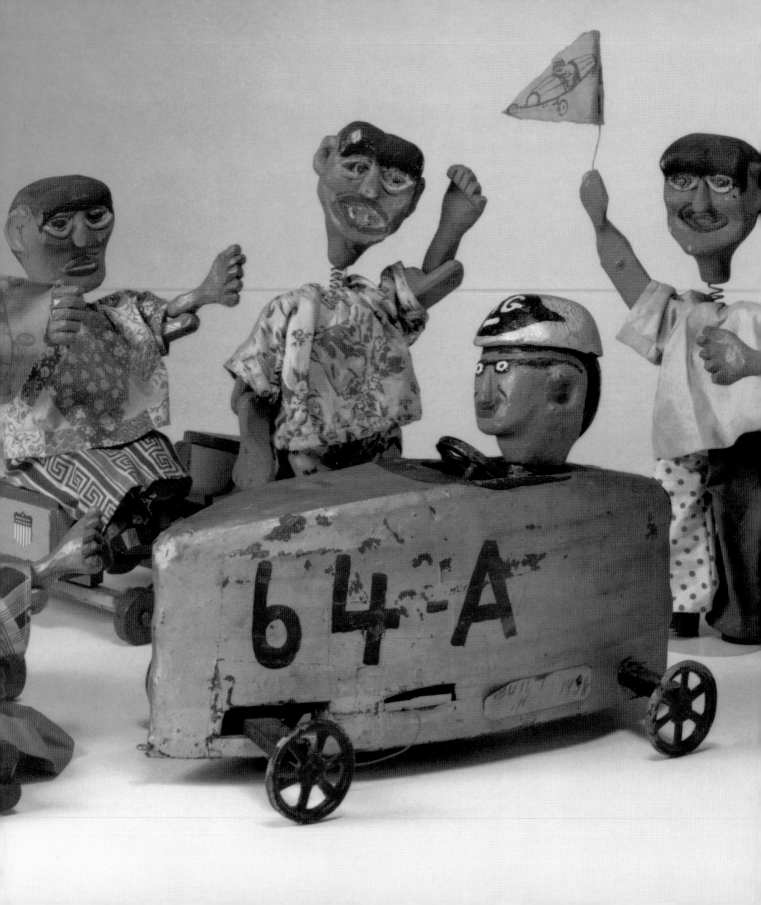

Made for Fun

There are many kinds of handmade childhood objects from dolls to toy wagons, but, surprisingly, some of the qualities we most look for in objects are not often found in works made to amuse children. We sought out ones that we felt displayed not only a magic visual quality but also an originality of thought.

One of the most whimsical toys we found is one we think of as the pre-Lego set (fig. 113). It also is the simplest in execution but the most ingenious in use. Along with some other attic junk on a flea-market table, we found a soiled box containing a number of basic geometric shapes of wood painted in bright and shiny colors. Also included were three stenciled faces and some rectangular slotted blocks. All these pieces fit together in a wide variety of ways to produce standing figures whose character could be greatly varied by interchanging the different basic shapes, but whose nature could never be other than sunny because of the smiling faces. Curious and engaged children could challenge their imaginations by rearranging the pieces to create one figure after another, having fun while doing so.

Toy animals have been made for children in many cultures over the centuries. We have found a few genuinely handmade ones like the parrot made by some parent or grandparent in the Pennsylvania Dutch area (fig. 114). Its appeal comes from its simplicity of design and the bright

Fig. 113
Pre-Lego Figures
Maker unknown
1920s
Painted wooden pieces
Assembled figures 10 1/2
to 11 1/2 high

colors that seem just right for a young child's toy. In its patient pose this bird is just waiting for a child to pull it and bring it to life.

The pair of stuffed baboons (fig. 115) display an amusing personality which is due to their maker's struggle to capture their naturalistic appearance. To ensure that the baboon's anatomy was

Fig. 114
Pull-toy Parrot
*Maker unknown, said to
be from Pennsylvania
Dutch country
ca. 1910
Painted wood
10 x 7 x 7*

Fig. 115

Docile Baboons

Maker unknown

1930s

*Cloth and fur with glass
eyes*

8 x 14

like sitting dogs on a leash than animals ready to spring. Their natural ferocity becomes tamed, their souls domesticated; the baboons become comic, personable figures for their lucky owner.

We acquired this family of toy giraffes (fig. 116) because of the stylish form the maker had chosen and the way it was applied so uniformly to each giraffe regardless of its size. Indeed, this fact alone intrigued us sufficiently to wonder whether they actually were made from some plant whose natural form provided the inspiration for making this set. We appreciated the maker's imagination and artistic sense, and we were convinced that these same qualities would also ensure that a child would treasure such a possession.

correctly represented, the maker twisted and shaped the armature in such a way that the baboons look more

Fig. 116

Family of Giraffes

Maker unknown

Date unknown

*Carved and painted wood
or plant material*

15 1/2, 10, 8, 5 high

Another group of toy animals of exceptional character are three stuffed pieces coming from the Pennsylvania Dutch area (fig. 117). Originally there may have been other animals in this menagerie, but we are grateful to have found the lumbering camel, the alert and quivering zebra, and the hunched kangaroo. What makes these toy animals unique and wonderful is their extraordinary realism. This impression is not due to any detailed physical description of their pelt, skin, shape, or facial features, but solely to the artist's ability to convey their body movements so convincingly. The camel, kangaroo, and zebra each

have the stance and gesture we associate with them. The maker was able to twist the wire skeleton into the basic shape of the animal, pad it, and cover the body with old stockings, then add a few stitches for eyes and parts are striking. Although the body shape is sleek, all its operating parts seem designed to hinder rather than assist its flight. The outsized, crudely joined tail, the bolted wings of different sizes, and the dangerously attached

zebra stripes. Presto, a miniature animal appeared that carried with it all the personality it exhibits in the real world.

The pleasure and fun of toys are often greater when they are made by their owner. And this is certainly true for the flying machine (fig. 118) that appears to have been hastily assembled from basement materials by a child shortly after World War I. The crudity of its construction and the disparity of its

landing gear and wheels all give it a special character. Whether it ever had a propeller or lost it in a nose dive— which is what we prefer to believe— we cannot guess. But this gaudy, painted object sent us a clear message of the youthful ideals of its maker and would-be pilot.

While the construction of the biplane was probably a solitary endeavor, the creation of the *Miniature Soap Box Derby* (fig. 119), complete with

Fig. 117

Animals Come to Life

Maker unknown, said to be from Pennsylvania Dutch country

ca. 1895

Wire armature, stuffed lisle stockings

6 to 8 high

banners, racing cars, drivers, and spectators no doubt was a joint venture of several boys and perhaps their parents. Soap Box Derbies were exciting competitions between boys eleven to fifteen years of age who made their own cars and coasted them in races down steep hills. These local events ultimately led to a national competition held in Dayton, Ohio, in 1933. Originally the racing cars were roughly made out of soap boxes or

Fig. 118
A Perilous Flying Machine
Maker unknown
1920s
Painted wood and metal
with rubber tires
18 3/4 x 32 x 42

114

orange crates with wheels taken from baby carriages or wagons. Later substantial prizes at the national level changed the amateur character of the racing cars but the name "Soap Box Derby" remained.

For a group of boys in the Boston area this annual event apparently sparked the idea of making and holding a miniature version of the derby. How it operated is a mystery, but we had the good fortune to find some remains of

Fig. 119a
Miniature Soap Box Derby
Arthur West, Allston, Massachusetts
ca. 1940
Painted cloth banner
37 x 76

Fig. 119b
Miniature Soap Box Derby
Maker unknown
ca. 1940
6 papier-mâché and fabric figures, 11 3/4 high; 1 racing car with driver, 9 1/4 x 7 x 12 1/2; 4 carved and painted wooden cars, 4 3/4 x 8 1/4 x 12

this enterprise at an antique show in York, Pennsylvania. We first spotted, from across the hall, two enormous painted banners showing racers in their cars. The banners alone were so compelling that we instantly wanted to

excitement of the hours they spent in making their cars and racing them down the hill. This miniature race must have helped to perpetuate those times throughout the course of the year. Whatever pleasure and profit ("5¢

Fig. 119c

Miniature Soap Box Derby

Peter Golden, Brighton, Massachusetts

ca. 1940

Painted cloth banner

37 x 73

acquire them. Only when we came closer did we discover that the banners were but part of a larger group of objects. They were accompanied by miniature spectator figures with heads marvelously modeled in papier-mâché and mounted on springs so they seem to be cheering lustily and waving their flags at the racers. In addition there was one racecar with a goggled and helmeted driver as well as a fleet of other, simpler racing cars. This compelling group easily conveyed the boys' commitment to both making their models and participating in the actual race itself. Their spirit is contagious and readily brings back all the

entry fee") they derived from it, we feel a debt of gratitude to Arthur West and Peter Golden for the part they played in creating these objects.

Concluding my comments about our discoveries with this ambitious work—combining as it does a fascination with mechanics and an awareness of visual form—is an especially appropriate ending for our discussion of works which would have elicited a smile from Leonardo. Although he certainly could have suggested improvements to these cars, he also would have cheered their efforts from alongside the racecourse.

Colophon

Design and Typography
Ab Gratama, assisted by John Fender

Typeface
Rockwell (Adobe)

Printing, Color Separation, and Binding
Cedar Graphics, Inc., Hiawatha, Iowa

Paper
Westvaco Satin 80-pound text

Photography
Gene Dieken, Barrett McDonnell, and
Tony Walsh

DATE DUE